IMAGES
of America

CAROLINA BEACH

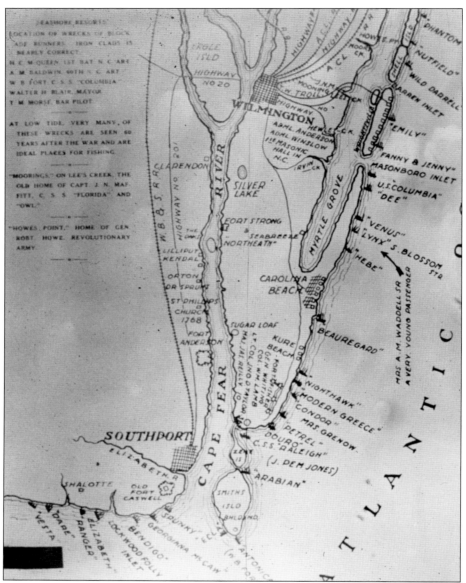

This map was drawn around 1925 primarily to show the Civil War shipwrecks along the Atlantic Coast. Among the fine print on the left side is the following statement: "At low tide, very many of these wrecks are seen 60 years after the war and are ideal places for fishing." (Courtesy of the New Hanover County Public Library, Robert M. Fales Collection.)

ON THE COVER: "Mansfield's Rides" is the name of this Hugh Morton photograph taken some time in the 1940s or 1950s. After packing up for the summer season, Mansfield followed the carnival circuit during the off-season. Morton was one of North Carolina's most famous photographers, and though he is best known for developing Grandfather Mountain in the western end of the state, he also documented on film the major scenes and events in Wilmington, Wrightsville Beach, and Carolina Beach. (Courtesy of the University of North Carolina Wilson Library, Hugh Morton Collection.)

IMAGES
of America

CAROLINA BEACH

Lois Carol Wheatley

ARCADIA
PUBLISHING

Published by Arcadia Publishing
Charleston, South Carolina

Printed in the United States of America

Library of Congress Control Number: 2011941782

For all general information, please contact Arcadia Publishing:
Telephone 843-853-2070
Fax 843-853-0044
E-mail sales@arcadiapublishing.com
For customer service and orders:
Toll-Free 1-888-313-2665

Visit us on the Internet at www.arcadiapublishing.com

*To my mother, who always said I should write
a book, and to my muse Frito-Lay*

CONTENTS

ACKNOWLEDGMENTS

My heartfelt thanks go out to everyone who supplied me with stories, photographs, leads, and encouragement in the process of pulling together all the parts and pieces in this collection. In particular, it would not have been possible without the unrelenting aid and assistance of Rebecca Taylor and the Federal Point History Center, where most stories were told, most photographs were scanned, and many discrepancies were (mostly) ironed out. Much of this book's content relies on oral histories and personal photo albums, and it was largely the members of the Federal Point Historic Preservation Society who generously stepped forward to share their time and their memories.

I would like to thank Doris Bame, Leslie and Darlene Bright, Gilbert Burnett, Chris Fonvielle, William Freeman, Charles Greene, Elaine Henson, Byron and Judy Moore, Frankie Stewart, Bob Sutton, Laurie Taylor, Jay Winner, and Juanita Winner. I also acquired some excellent photographs from the North Carolina Room at the New Hanover County Public Library, the Cape Fear Museum of History and Science, the North Carolina State Archives in Raleigh, the Underwater Archeology Laboratory at Fort Fisher, the Wilson Library at University of North Carolina, Chapel Hill, the Natinoal Guard Training Center and North Carolina Military History Museum in Kure Beach, and the Library of Congress in Washington, DC.

Finally, I relied on a number of local histories, a couple of them published by Arcadia Publishing, which I have listed at the back in the bibliography.

INTRODUCTION

Surprisingly little is known about the Cape Fear Indians, the earliest human inhabitants of Carolina Beach. Historians guess the tribe might have been part of the Sioux nation and that they were nomadic, leaving small deposits of relics here and there throughout the region, not to mention huge mounds of oyster shells. Other possible connections are Waccamaw, Algonquin, or Tuscaroran, and one theory is that whatever was left of the tribe—after a smallpox epidemic and numerous clashes with white settlers—wandered off to join the Peedees in South Carolina.

William Hilton's journal of his 1662 expedition reported an ambush along the Cape Fear River by a tribe he described as "maybe Eastern Sioux." Maurice Moore of the Orton Plantation family (across the river near Brunswick Town) defeated some portion of the native population in 1715 at a site known as Sugar Loaf, which is now part of Carolina Beach State Park. Moore claimed he had vanquished the last of them, but clearly, native blood commingled freely with African blood during the ensuing years of slavery, and without question, those descendants live among us still.

A ferry between Brunswick Town and Sugar Loaf was begun in 1727 by Cornelius Harnett Sr., the father of a Revolutionary War hero and delegate to the Continental Congress. The peninsula acquired the name Federal Point soon after the US Constitution was adopted in 1787.

Slave watermen dominated the boat traffic on the Cape Fear River. Using sails, poles, and oars to transport their masters' freight to market, they stood atop flat rafts in the tradition of Huckleberry Finn or knelt or sat in cypress dugout canoes. The smaller vessels were *periaugers* or *cooners* and were made of two logs fixed together with a third keel log between them, rigged with one or two masts. Cooners might be up to three logs put together, measuring about 28 feet long. A big boat with a ton or more of freight would have had two to four slaves working the oars and the sails.

A slave owner did not send along an overseer, as that would have been totally impractical, and so slave watermen were left largely on their own and were often in great spirits, usually singing. Their relative freedom made them prime suspects whenever there was a slave uprising or a runaway, and the swamps along the river were prime hiding places for fugitive slaves, criminals, debtors, and desperate women fleeing their marriages. Their straits were so dire that they would share the woods with panthers, snakes, bears, and alligators.

At night, the plantation slaves along the river pushed their dugout canoes from their hiding places among the marsh grasses and did some nocturnal fishing. Slave owners did not permit them any kind of instruments, especially drums, for fear they would use them to send secret messages. When they gathered at the water's edge, they did a thing called jigging, a sort of syncopated rhythm that they set up and built on, clapping and hitting their palms on their thighs, legs, and chest.

The 1850 census listed Alexander Freeman as a 61-year-old mulatto fisherman with a wife (her name, Charity, was not listed) and two sons, Robert B., age 18, and Frank, age 11. That same census reported 650 free black men in the Wilmington area, 3,570 whites, and 2,873 registered slaves. Above and beyond being a free man of mixed heritage, Freeman owned more than 200 acres of paradise with sandy beaches underfoot, seagulls spiraling overhead, and live oak trees shading his path. The surrounding waterways supplied him with an abundance of fish, shrimp, oysters, and clams, sufficient to feed his family and provide a livelihood. His land was surrounded by slave-owning plantations that produced mostly indigo, cotton, peanuts, and rice.

Thus began the extremely improbable good fortune of the Freeman family. Almost certainly, Alexander Freeman inherited from the Cape Fear Indians the knowledge he used to weave nets from indigenous fibers, to bait traps, and to read the tides, the currents, and the phases of the moon. His West African heritage would have taught him that the ancestors are all around in the form of clouds, rain, barking dogs, and calling birds, and they communicate with the living

through the messages of nature. Clearly, they knew where to find good fishing and continued to inform many generations of Freemans to follow.

Robert Bruce Freeman inherited his father's land and increased his holdings by a factor of more than 10. At the height of his power, he was one of New Hanover County's largest landowners, holding title to as much as 5,000 acres stretching from north of present-day Snow's Cut to south of Carolina Beach Lake. His holdings also included a little slip of a barrier island between Myrtle Grove Sound and the Atlantic Ocean known today as Freeman's Beach.

Freeman made his money in the timber business and also continued in the family fishing tradition. He acquired a mansion built of coquina, a rock made up of compacted shells, with an oak-lined avenue extending to the ocean and an equally scenic route going in the other direction to a river landing near Sugar Loaf. Freeman settled in with his first wife, Catherine, and named his vast estate the Old Homestead Tract.

Across these scenic vistas a lot of foot and mule-cart traffic trudged between Wilmington and Fort Fisher during the Civil War, including infantry soldiers training and on the march to defend the fort at the mouth of the Cape Fear River. This was the last portal open after Union forces had closed all others. Due to its shallow waters and treacherous shoals, the large Union ships chased the smaller blockade-runners only so far and then backed off rather than come upon notoriously dangerous reefs or come within range of Fort Fisher's guns.

When at last Union troops stormed the fort and shut down the only remaining Confederate supply line, it was the end of the road for General Lee's troops in Virginia and the beginning of a whole new era throughout the South. A new social order moved in that would be slow to formulate. The master-and-slave construct would have to be replaced with something else, and the structure of that would not very soon fall into place.

The Wilmington race riot of 1898 resulted in some of the harshest Jim Crow laws to be enacted in the South, and among many things, the beach became segregated. A multiracial group of developers started a black resort called Shell Island at the north end of Wrightsville Beach in 1923, but that burned to the ground under suspicious circumstances in 1926, and the developers had better sense than to try again. Most of the beach on Federal Point was still black-owned, and an all-black resort known as Seabreeze took shape on the Freeman property. Its lasting legacy was the introduction of a new style of dance and of R&B music, first known as race music, later considered beach music, and now the ongoing sound track for the ever-popular shag dance.

At the beginning of the 20th century, Carolina Beach was a popular day-trip destination that could be reached by hopping a steamship in Wilmington to cruise down the Cape Fear River and then boarding a small train to cross the peninsula. By the 1920s, the beach beckoned to distant visitors seeking to spend a week, a month, or a summer at the seashore, and a paved road from Wilmington resolved the transportation issue.

By the 1940s, a permanent year-round population began to take root, a community that had to invent itself and, at the same time, withstand a spate of fires and hurricanes. The boardwalk fire of 1940 consumed two oceanfront blocks, and Hurricane Hazel in 1954 left very few structures standing. What survived these disasters, coupled with what was rebuilt with greatly improved fire- and flood-proofing materials and techniques, are all living proof of Nietzsche's old adage, "what doesn't kill us makes us stronger."

This narrative covers the Federal Point Peninsula running from north to south, starting with Seabreeze. The Army Corps of Engineers created Snow's Cut in 1930 as a nautical thoroughfare, slicing straight through the Old Homestead Tract and, at the same time, creating a clear dividing line between the black community and the developing Carolina Beach resort. The Kure family initially had holdings in Carolina Beach before moving a mile or two to the south to start a beachfront development of its own. The Winner family, generally associated with Carolina Beach, had an early stronghold on Kure Beach and Fort Fisher. And down at the southern tip of the former peninsula (now an island known as Pleasure Island) is the Fort Fisher of Civil War fame, which was also the one-time home of the late, great Fort Fisher Hermit.

One

SEABREEZE

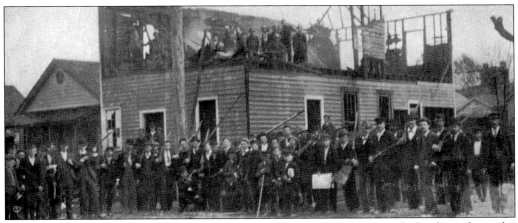

The Wilmington race riot of 1898 launched Jim Crow on his fledgling flight throughout the Lower Cape Fear region. In this photograph, white supremacists posed before the smoldering remains of the building that housed the city's black newspaper after throwing the printing press into the river and torching the building. During the ensuing riot, they shot up the town, killed an untold number of black citizens, and overthrew the mixed-race city council. Then, they appointed themselves to public office and imposed some of the earliest and harshest segregation laws in the South. Down on Carolina Beach south of Wilmington, descendants of Robert Bruce Freeman were in a unique position, located at a sufficient distance from Wilmington and Wrightsville that they stood a reasonable chance of staying out of harm's way. Their relatively remote location also facilitated the distillation of bootleg moonshine during Prohibition. Ellis Freeman sold the first Seabreeze lots in 1921, and in that same year, Freeman Café opened. (Courtesy of the North Carolina Public Library, Robert M. Fales Collection.)

Lena Davis was 16 years old when she married Robert Bruce Freeman, a widower in his late 50s. It is rumored that she came from Brunswick County, and Freeman paid $300 for her. The real estate tycoon died in 1902 and acknowledged 11 children by two wives. To the five surviving offspring of Catherine, his first wife (a sixth had predeceased him), he left 57 acres apiece. To the six children of Lena Davis, he left a total of 57 acres that was to be divided among them all. The inconsistencies of that legacy have never been worked out in what one might call an amicable way. (Courtesy of William Freeman.)

Victoria Lofton built the first hotel in Seabreeze, and at the time, she also had a hotel in Shell Island. The 25-room Lofton Hotel and Dance Hall, with a cement walkway leading to the water's edge, held a huge grand opening celebration in 1924. In 1925, Simpson's Hotel opened. In 1929, Frank Herring's seven-piece orchestra performed for the grand opening of the Russell Hotel. Seabreeze visitors arrived in droves. Farm workers came in by the truckload to squander their hard-earned wages on a weekend of eating, drinking, and dancing. Military men converged on the resort from numerous local bases, and vehicles were parked on both sides of Seabreeze Road all the way out to Carolina Beach Road. In 1925, the Wilmington Bus Company opened a Wilmington-Seabreeze route. By the 1930s, the resort had anywhere from 30 to 40 bars, restaurants, and dance halls. The music was an entirely different kind than the white resorts were playing, and it was cranked up to a high decibel level that could be heard for miles around. (Courtesy of the New Hanover County Public Library.)

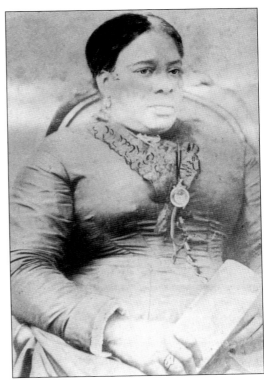

A photographer's shop sent visitors home with souvenir photographs, and young Darnell Freeman became a roping and riding cowboy. An amusement park opened in the summertime with a Ferris wheel, a hobbyhorse (like a merry-go-round), chair planes, a carousel, the Octopus, and the Caterpillar. A fellow named Charlie ran the gambling tables, and his motto was "beat my roll, take my gold." A Native American known as Snake Man set up a sideshow tent, and one of the attractions he offered was "the Woman With No Body," which actually was his extremely short wife in a darkened setting that only revealed her head. He also ran a candy store and a small circus and mounted an impressive snake display. (Courtesy of William Freeman.)

A portion of what used to be Daley's Breezy Pier Restaurant still stands, though one wouldn't want to walk out on that pier now. Daley's had a two-story covered pavilion at the end of the pier where bands played and people fished and crabbed. Clam fritters were the number one selling food item in all the Seabreeze eateries and cost a nickel. Barbecue Sam's had a pigpen in the backyard and an open pit. "Seabreeze had the best seafood," William Freeman said. "You couldn't beat it and my family knew how to cook it because that's what they did." (Courtesy of William Freeman.)

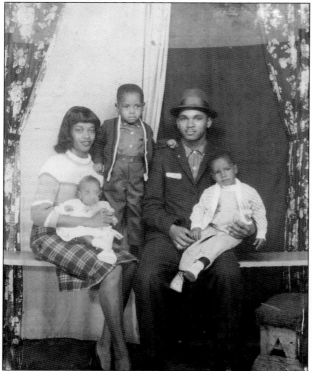

William Freeman, born in 1941, grew up in Seabreeze and raised his own children in his grandfather's house. Mae holds Sharon on her lap, Darnell is standing, and Rodney is on William Freeman's lap. "It was fun, it was fun, it was fun," he said. "For black people to be able to come to a place like this, come and dance and kick up and have fun the whole weekend, that had to be a great thing for us psychologically. All these places, blacks owned all this. Every place there was owned by black people. It was far more valuable than we realized it was." (Courtesy of William Freeman.)

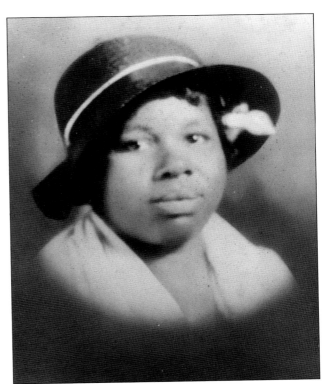

Jim (below) and Winnie (right) Blackledge owned the Blue Moon on Carolina Beach Road. They also owned Salem Lodge in the central Seabreeze business district. (Both, courtesy of William Freeman.)

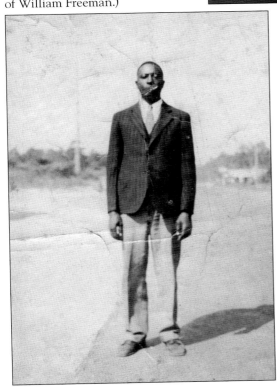

Recipes for clam fritters were closely guarded family secrets, and fritters varied from one eatery to the next. It would be safe to say that the basic recipe included eggs, milk, flour, and clams. (Courtesy of William Freeman.)

Seabreeze businesses advertised regularly in the *Wilmington Star-News*. (Courtesy of the Federal Point History Center.)

The legend of Malcolm Ray "Chicken" Hicks is a local favorite. Hicks was a teenager in 1941 when he visited Seabreeze and picked up on the R&B music and dance, which he already knew something about from his upbringing in Durham. Jukeboxes, which were called piccolos, were in every jump joint, and Hicks had an appreciation for what was then called race music. He also had a connection with a fellow named Parker who loaded up the jukeboxes at both Seabreeze and Carolina Beach and was able to persuade Parker to put some of the same records he would have heard in Seabreeze into the jukeboxes in Carolina Beach. The rest, as they say, is shag-dancing history. (Courtesy of Lynda Hicks.)

Hicks married his longtime dance partner Lynda Myers and, over the years, did demonstrations and exhibition dancing right up until his death in 2004. He hitchhiked to Myrtle Beach in the early 1940s, where some of the same sort of dancing was going on, and snuck into a black nightclub, which was called "jumping the Jim Crow rope." Eventually, Carolina Beach imposed minimum square footage requirements on the small jump joints and forced them out of business. A whole herd of shag dancers left permanently for Myrtle Beach, which now calls itself "the Home of the Shag." Around the same time, the all-white Lumina Pavilion on Wrightsville Beach prohibited "shimmy-shiver" dancing. If a violation was detected, the orchestra stopped playing, and the drums pounded out a warning signal. If the behavior persisted, a dancer was expelled from the dance floor. The new music and dance craze also met with stiff resistance in Carolina Beach, but it nevertheless spilled over from nearby Seabreeze like a giant rogue wave. (Courtesy of Lynda Hicks.)

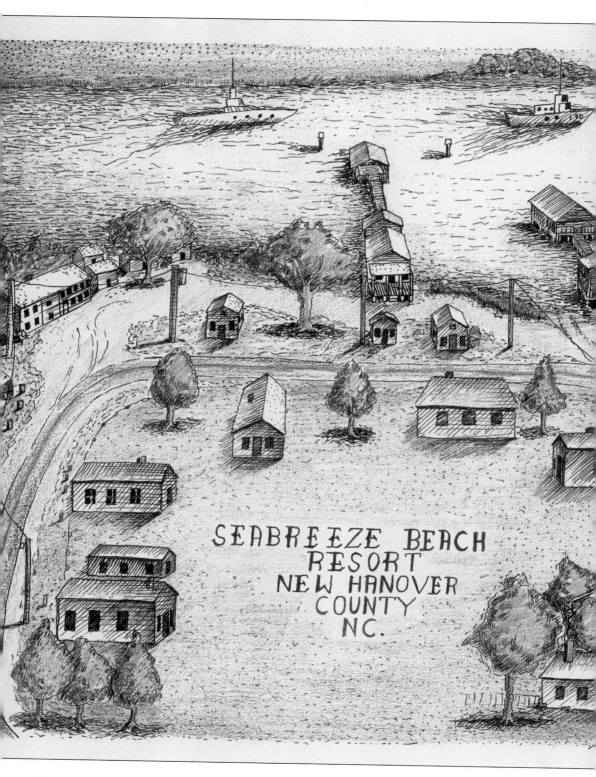

SEABREEZE BEACH
RESORT
NEW HANOVER
COUNTY
NC.

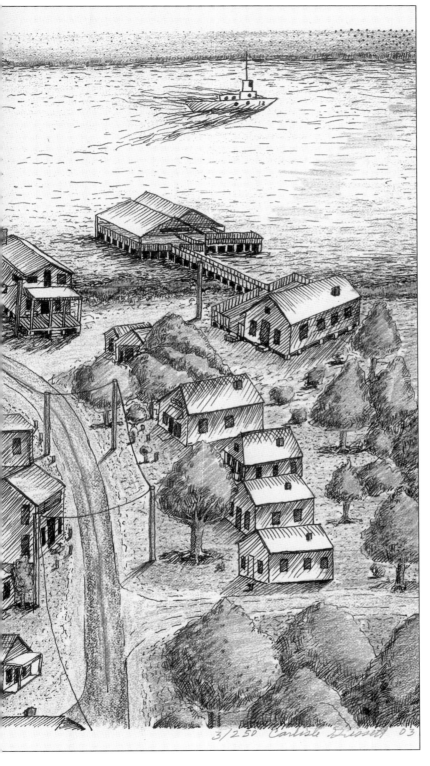

3/250 Carlisle Grisseid 03

Artist Carlisle Grisseid drew this map in 2003 based on the collective memories of those who gathered for Heritage Day to recall it. The top of the map is east, with a slender strip of Bop City showing above Myrtle Grove Sound. Along the Seabreeze shoreline, the pier on the right was Daley's Breezy Pavilion. The small building next to that was Cornelia Freeman's hot dog stand, adjacent to her brother Bruce's tavern. The pier on the left was Grover's Pier, where Grover Freeman launched his ferry to Bop City and also ran a dance hall and rooming house. Other establishments shown on the map—not a complete representation of the business district by any means—are Joe Junior's, Aunt Olive's, Buster Greenfield's, Thomas and Irene Robinson's White and Green, Irvin's Place, Miss Sadie's Place, and the Seabreeze Gentleman's Club. (Courtesy of William Freeman.)

17

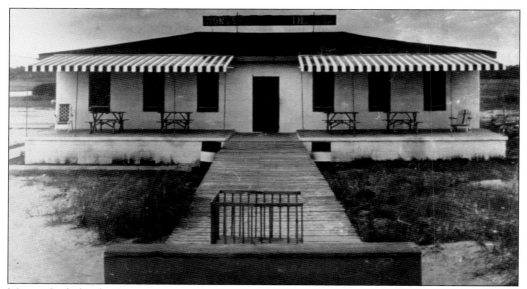

Monte Carlo by the Sea was out on the beach strand then known as Bop City, located on the far side of the Myrtle Grove Sound. Seabreeze visitors had a bit of trouble getting there. If they tried to skirt around the sound to the south via Carolina Beach, they were arrested for trespassing. Grover Freeman ran a small ferry service as a direct route that was unobstructed by representatives of the local precinct. (Courtesy of the Cape Fear Museum, Frank Hill Collection.)

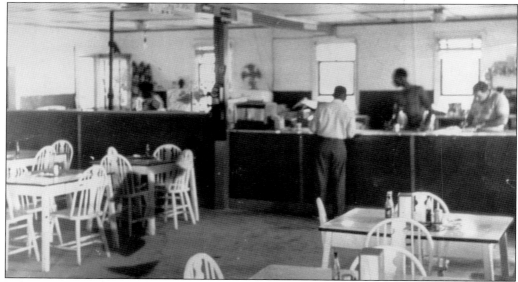

Lula Freeman married Frank Hill, and the couple proposed building a boardwalk across the sound to the ocean beach. Various members of the Freeman family opposed the plan, believing—probably correctly—that such a structure would obstruct boat traffic and therefore not be well tolerated by the white neighbors. This ultimately escalated the ongoing family feud, and in 1921, Frank and Lula Hill packed up to return to Frank's roots in Jamaica, New York. However, they came back to build Monte Carlo by the Sea in 1951, some 30 years later. Monte Carlo by the Sea was the last hold-out after other Seabreeze businesses closed down. (Courtesy of the Cape Fear Museum, Frank Hill Collection.)

An unidentified couple enjoyed oceanfront dining where patrons ate 35¢ hamburgers and fish sandwiches or paid $1.50 for a seafood platter before Hurricane Hazel completely demolished Monte Carlo by the Sea in 1954. The Hills rebuilt with their own hands using salvaged materials, but other hurricanes followed. Then, in the 1960s, an even more devastating force struck a fatal blow to this thriving enterprise. It was called desegregation. (Courtesy of the Cape Fear Museum, Frank Hill Collection.)

The Hills had two daughters, Doris and Evelyn, and the girls had cousins in the Freeman family. Evelyn became a lawyer and she filed suit to allow nature to run its course and close the Carolina Beach Inlet. Erosion from the inlet had reduced the beach from 270 acres in the early 1950s to less than half that. The suit was unsuccessful, and dredging has continued to maintain the inlet. The children in this photograph are unidentified. (Courtesy of the Cape Fear Museum, Frank Hill Collection.)

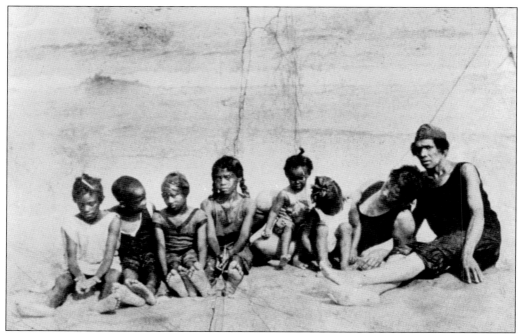

Pictured are Frank and Lula Hill (right) with extended family. Frank Hill's family had an interesting background. His father, Lincoln Hill, was the butler and chauffeur for James Sprunt, a prominent Wilmington businessman credited with the invention of a cotton compression apparatus that could compact up to four times as many bales of cotton into the hulls of ships than had previously been stored for transatlantic shipments. Sprunt had a huge warehouse on the riverfront, and Lincoln Hill was the first black person to drive a car in Wilmington. (Courtesy of the Cape Fear Museum, Frank Hill Collection.)

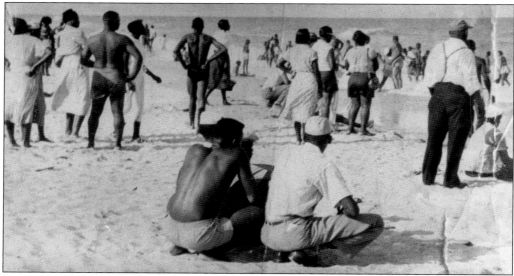

Spectators gathered to watch surfing club trials held in the surf that pounded Bop City, also known as Freeman's Beach. There was nothing on the beach before the Hills built there in 1951, and there is nothing there today. (Courtesy of the Cape Fear Museum, Frank Hill Collection.)

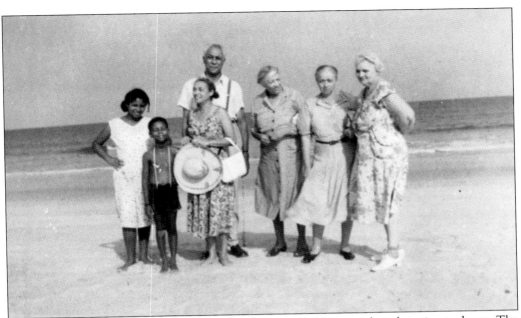

White visitors were not at all unusual, and they were not all teenage boys learning to dance. The Seabreeze phenomenon was contemporaneous with the Harlem Renaissance, and while there were other black communities that sprang up along the coast—Atlantic Beach in South Carolina and Ocean City on Topsail Island in North Carolina—there were not many other full-fledged black resorts with all the amenities. The only comparable places anywhere at all were Inkwell in Massachusetts and American Beach in Florida. (Courtesy of the Cape Fear Museum, Frank Hill Collection.)

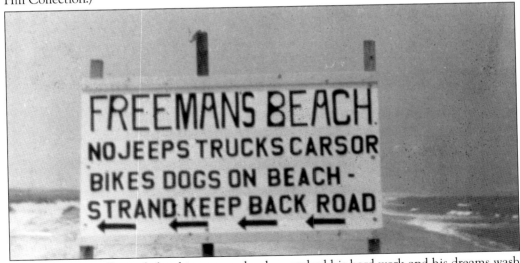

Frank Hill was well entitled to his rage, and as he watched his hard work and his dreams wash out to sea he was also watching off-road vehicles churn up what small amount of turf remained. Hill erected this sign, an ultimate irony in terms of the present-day occupants of Freeman's Beach. Today, the Town of Carolina Beach operates the strand and charges admission so that jeeps, trucks, cars, bikes, and dogs can camp out. (Courtesy of the Cape Fear Museum, Frank Hill Collection.)

Snow's Cut Convenience Store, found at the intersection of Seabreeze and Carolina Beach Roads before the bridge, was in rough shape when William Freeman first bought it from a cousin in 1980. Visitors passing through this very visible location in the 1940s watched members of the Freeman family build boats in the side yard. The sight of meticulous sawing, whittling, and fitting of handcrafted parts often inspired passersby to order custom-built boats from these craftsmen. (Courtesy of William Freeman.)

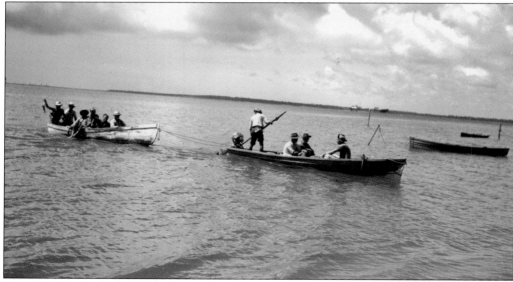

The Freeman family was legendary for its fishing prowess and had a "spot" that was all its own near Fort Fisher. Other fishing boats respected the Freemans' territorial rights and did not compete for that spot. The family owned one motor and three boats, so it was not uncommon to see them string at least two boats together with a rope. Customers, both black and white, looked forward to the Freemans' return with the catch of the day, and at the time, black people were allowed on Carolina Beach as long as they were servicing white people. (Courtesy of the North Carolina State Archives.)

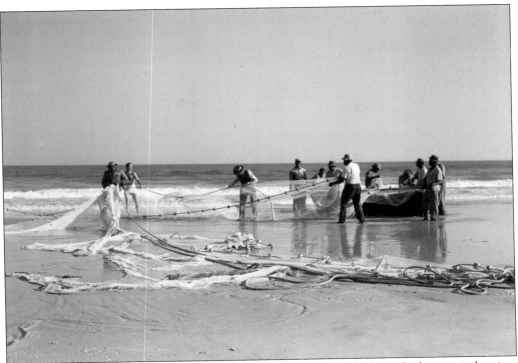

The Freeman brothers cast wide nets to catch their bait, typically shad, menhaden, pogie, herring, and whatever other small fish swim these waters in large numbers. Throughout the day, the Freemans strung up their catch on sea oats, and at the end of the day, they would charge 25¢ per string. Kids looking forward to a good meal would watch for the Freeman boats and swim out to help pull them ashore. (Courtesy of the North Carolina State Archives.)

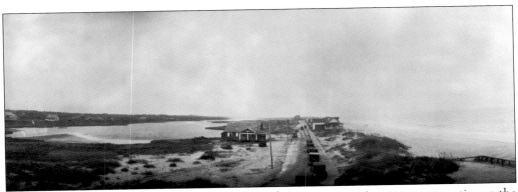

This 1930s-era aerial view of Carolina Beach's northern extension gives some perspective on the lay of the land. On the right side is the ocean, and straight ahead is present-day Freeman's Beach (the former Bop City). Left of center is Myrtle Grove Sound, and at the far left, with its coastline curving back toward center, is Seabreeze. (Courtesy of the New Hanover County Public Library, Louis T. Moore Collection.)

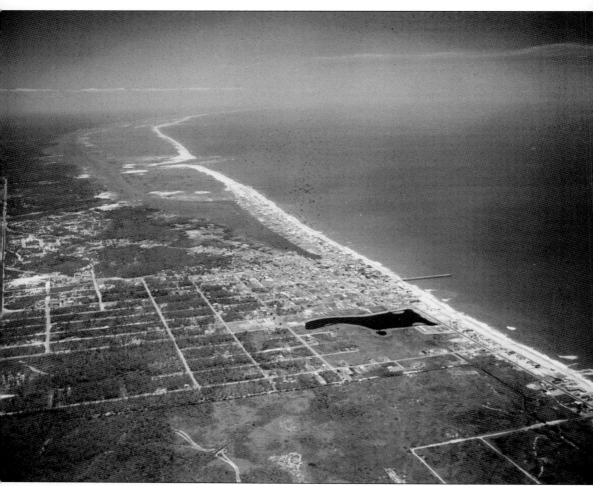

The Army Corps of Engineers warned that the proposed Carolina Beach Inlet would cause substantial erosion to Freeman's Beach but then granted the permit to create it. The inlet was 3,900 feet in length, and the initial blast opened a 22-foot entrance on September 2, 1952. By 7:00 p.m. that same day, the mouth of the Carolina Beach Inlet was 50 feet wide. Over the years, the inlet has steadily eroded Freeman's Beach, while public and private concerns have paid millions of dollars to keep it open. (Courtesy of the University of North Carolina Wilson Library, Hugh Morton Collection.)

During the 1990s, the Freeman family began a series of family reunions that was from the start open to non–family members. Eventually, this event expanded into Seabreeze Heritage Day and continued into the early 2000s. The reunions were held in the home of Roscoe Freeman, William's grandfather, beginning in 1997. Roscoe was struck and killed by an ambulance out on Carolina Beach Road in the 1960s, so he was not at home to welcome the 150 or so people who showed up on his doorstep to cook clam fritters and reminisce about the good old days. It was such a good time, reminding everyone of good times gone by, that they decided to do it again, throw it open to the public, and take it to the streets. (Courtesy of William Freeman.)

Edna Freeman had a great time at the reunions. She is a granddaughter of Robert Bruce Freeman, daughter of Roscoe Freeman, and mother of William Freeman. (Courtesy of William Freeman.)

25

The first Seabreeze Heritage Day was in 2000, with William Freeman as the parade marshal. The Wrightsboro Saddle Club was in the parade line-up, along with the East Coast Cruisers, the Coastal Cruisers Car Club, Port City Wheelers (doing cycle stunts), and the fire and sheriff departments (making their vehicles backfire). Rod Cruise with Coast 97.3 FM played loud music to a big crowd and demonstrated a dance move called the electric slide. Kids went on pony rides and had their faces painted. The festival went on like this for the next few years and stopped after 2004. Miss Sadie's Place can be seen in the background behind the parade; it, unfortunately, burned to the ground not long after this picture was taken. (Courtesy of William Freeman.)

William Freeman cooked up a big old batch of gumbo when he really should have been frying clam fritters. The fellow who made clam fritters claimed he sold 3,000 of them during Heritage Day. (Courtesy of William Freeman.)

The Freeman family still gathers for reunions at Mount Pilgrim Baptist, a historic church in the Seabreeze community. The church dates back to the 19th century, so it has seen Seabreeze come and go, as some might say, with the wind. (Courtesy of William Freeman.)

William's late wife, Rachel, was the hostess of the early Freeman reunions and one of the organizers of Heritage Day. She was on the New Hanover County School Board and very influential in civic matters. (Courtesy of William Freeman.)

Joseph "JoJo" McNeil is shown here with Rachel Freeman delivering the keynote address at a 1991 Williston School reunion. McNeil is a Seabreeze native nationally famous as one of "the Greensboro Four," a group of black activists that staged a sit-in at a Woolworth's lunch counter in 1960. (Courtesy of William Freeman.)

Two

CAROLINA BEACH

Capt. John Harper ferried beachgoers back and forth from Wilmington's dock to a pier he built on the river side of Robert Bruce Freeman's property. Harper formed a partnership with others known as the New Hanover Transit Company to develop, among other things, a dance pavilion and a hotel on the beach. (Courtesy of the New Hanover County Public Library, Robert M. Fales Collection.)

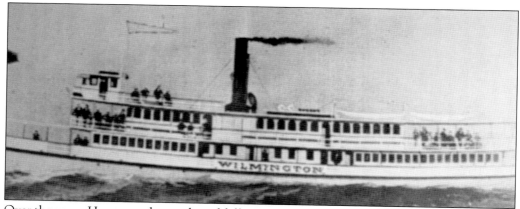

Over the years, Harper used a number of different steamers to make the run from Wilmington to Carolina Beach, but the one that lives on in local memory is the steamer *Wilmington*, bought in Wilmington, Delaware, and therefore already named *Wilmington*. She was 130 feet long, with a 23.5-inch beam, and drew 6.5 feet. Built in 1882, she had three decks and carried as many as 500 passengers. At first, she launched from the foot of Market Street in downtown Wilmington, but later, Harper constructed a new wharf at the foot of Princess Street, and he began launching from there in 1912. (Courtesy of the New Hanover County Public Library, Robert M. Fales Collection.)

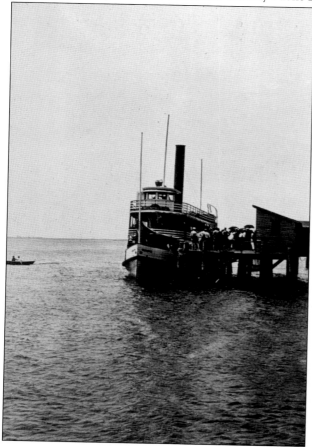

Harper discharged passengers from the steamer on the river side of the peninsula and then had to move them two or so miles to get them to the beach. The pier became known as Harper's Pier and was near Sugar Loaf, located at the present-day confluence of Snow's Cut and the Cape Fear River. Later, he built a larger deep-water pier at Doctor's Point, farther north. (Courtesy of the New Hanover County Public Library, Robert M. Fales Collection.)

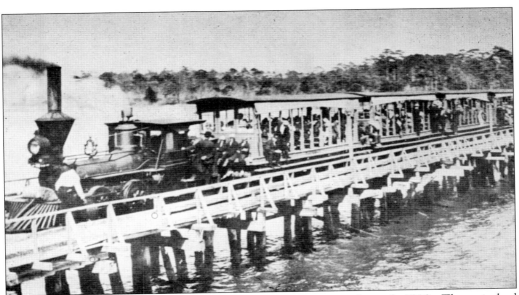

The *Shoo-Fly* was an antique before Harper put it into service in the early 1900s. The train had a steam engine, five open passenger cars, and one flat car. Harper obtained permission from Robert Bruce Freeman to lay track across his property in exchange for free train rides for the Freeman family. But, of course, he struck that deal before segregation prohibited the Freemans from visiting Carolina Beach at all. (Courtesy of the New Hanover County Public Library, Robert M. Fales Collection.)

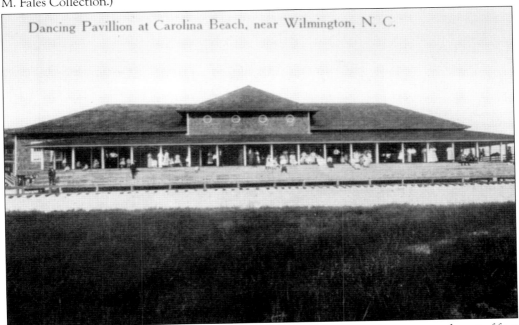

The *Shoo-Fly* stopped in front of a dance pavilion, the end of a voyage that consumed most of four hours. The first dance pavilion burned on December 10, 1910, in an infamous boardwalk fire that also destroyed Harper's hotel and several enterprises belonging to Hans A. Kure, the founder of Kure Beach. (Courtesy of the New Hanover County Public Library, Robert M. Fales Collection.)

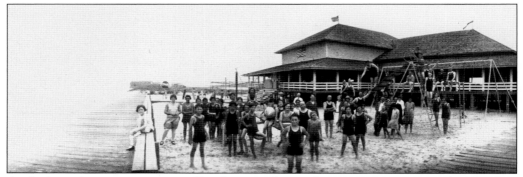

A rebuilt pavilion was two stories tall and apparently went by two or more names, either Carolina Casino or Carolina Moon. "Casino" probably had little or nothing to do with gambling, though the pavilion possibly hosted some bingo games. (Courtesy of the New Hanover County Public Library, Louis T. Moore Collection.)

The new pavilion had a playground with swings and seesaws. (Courtesy of the New Hanover County Public Library, Louis T. Moore Collection.)

This eastward view from Snow's Cut Bridge depicts an astonishing absence of condominiums. In 1930, the Army Corps of Engineers was well aware that the cut would create an environmental hazard for both the river and the sound—as indeed it turned out to be. Maj. William A. Snow was a district engineer for the corps who supervised the $5.3-million dredging work performed by private contractors. (Courtesy of Doris Bame.)

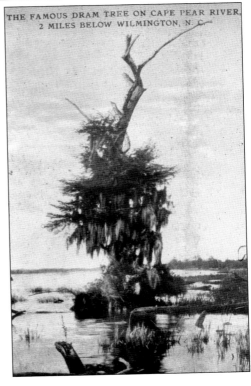

THE FAMOUS DRAM TREE ON CAPE PEAR RIVER, 2 MILES BELOW WILMINGTON, N. C.

The Dram Tree was a famous landmark for ships heading up the Cape Fear toward the port of Wilmington. According to song and legend, when sailors sighted this ancient cypress tree, they knew that they were minutes away from reaching the port and that it was prime time to drink their last dram of rum before docking. (Courtesy of the New Hanover County Public Library, Robert M. Fales Collection.)

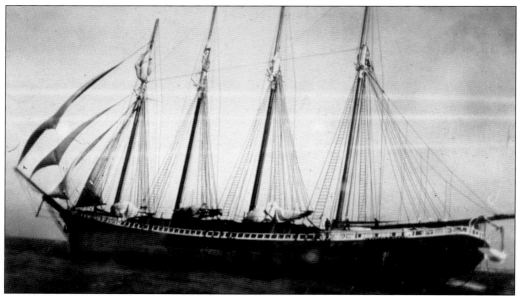

Enormous sailing ships from Europe had a tough time navigating the shallow waters of the Cape Fear, and commercial enterprises dredged the river many times to allow passage of increasingly larger ships. In a classic case of unintended consequences, the dredging introduced saltwater from the ocean into the swampy rice plantations on the riverbanks and completely wiped out the rice crops the large ships had been transporting. (Courtesy of the New Hanover County Public Library, Robert M. Fales Collection.)

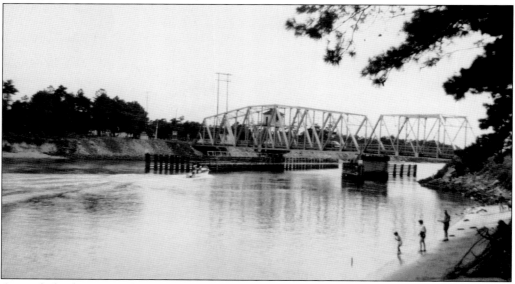

An early bridge across Snow's Cut was a swing bridge that turned on a wooden axis to stop vehicular traffic and admit boat traffic. It was torn down in 1966. "Dunc" W. Stewart was the bridge tender. One striking feature of this photograph is the contour and elevation of the shoreline before erosion carved away any beach-type water-access areas. The banks of Snow's Cut are far more precipitous today, and accessing the water from certain parts of the shore is a physical feat. (Courtesy of Doris Bame.)

34

From left to right, Linda Rosnick, Bob Sutton, and Betsy Sutton came off a day aboard a Winner fishing excursion with a huge string of fish in the 1940s. (Courtesy of Robert Sutton.)

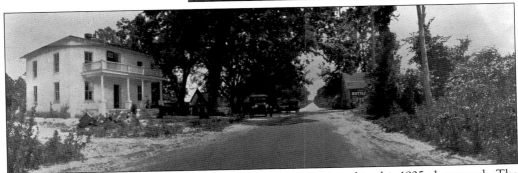

Highway 421 leading to Carolina Beach was a rural two-lane road in this 1925 photograph. The road was not widened to four lanes until the 1950s. (Courtesy of the New Hanover County Public Library, Louis T. Moore Collection.)

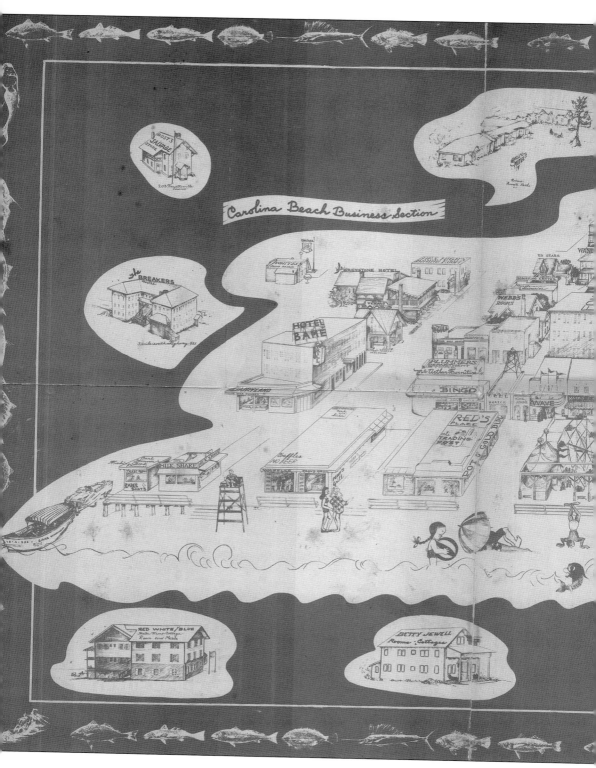

Carolina Beach Business Section

Ray Fountain's family ran the Hotel Royal Palm. W.G. Fountain owned and managed the hotel from the time it was built in 1935. He was also mayor of Carolina Beach. (Courtesy of Charles Greene.)

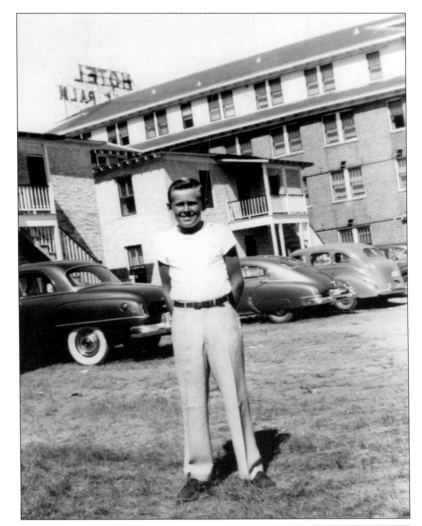

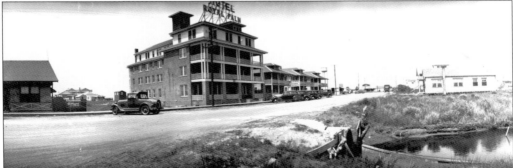

Located on Harper Avenue, Hotel Royal Palm underwent extensive renovations in 1983 and at that time changed its name to Hotel Astor. It burned in 2005. Next door to the right is the complex of Fountain's Rooms and Apartments. (Courtesy of the New Hanover County Library, Louis T. Moore Collection.)

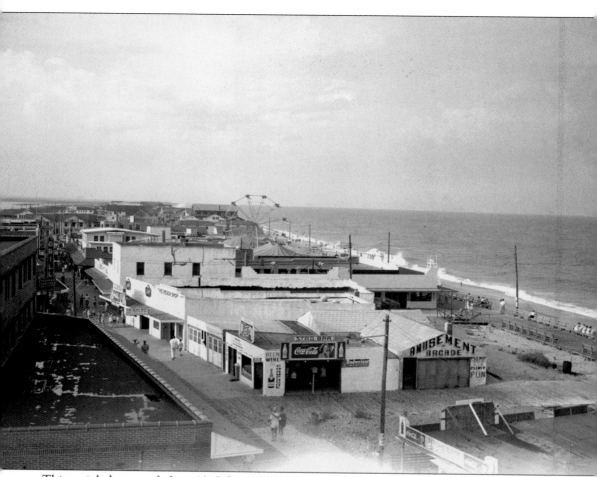

This aerial photograph from 1945 shows a boardwalk with a significantly different configuration than the one in place today. Now, a concrete promenade cuts through the center of the shops and eateries, and the amusements are mostly on what one might call the second row. (Courtesy of the North Carolina State Archives.)

In another branch on the Burnett family tree, the little girl on the right is young Katie B. Hines, for whom the Carolina Beach Senior Center is named. (Courtesy of Gilbert Burnett.)

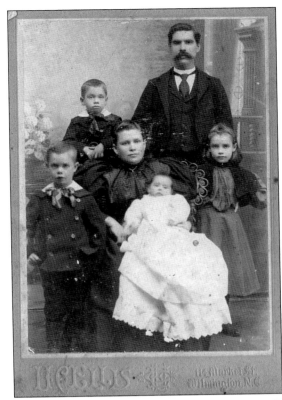

The turn-of-the-century Burnett family included a cowboy, the fellow wearing black and holding a baby. He was Gil Burnett's grandfather, and ran his herd in the Fort Fisher area. "He had free-range, just like in Texas, in the late 1800s," Burnett said. His granddaddy gave up his cowboy ways when he got married and moved to Pender County, and he came back to Carolina Beach in 1936 to build a cottage that Hurricane Hazel destroyed in 1954. (Courtesy of Gilbert Burnett.)

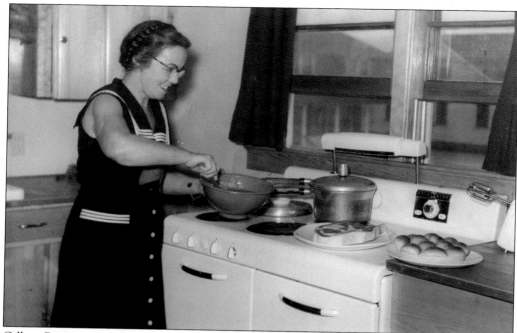

Gilbert Burnett's mom was surrounded by all the state-of-the-art kitchen appliances at the family's beach cottage, where she could mix and bake every bit as well as she could at their home in Burgaw. (Courtesy of Gilbert Burnett.)

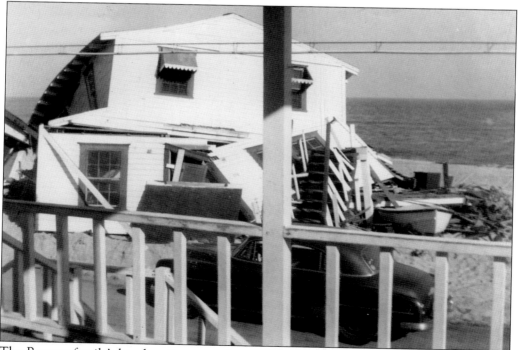

The Burnett family's beach cottage was destroyed by Hurricane Hazel in 1954. (Courtesy of Gilbert Burnett.)

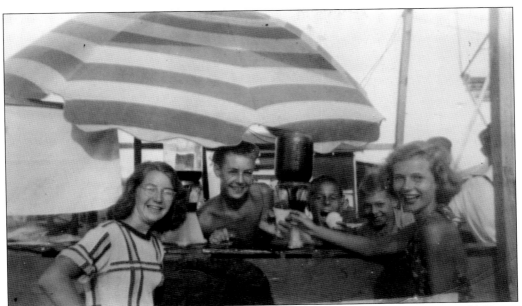

Gilbert Burnett (center) sold snowballs for Mansfield Amusements when he was 11 years old. He got into a dispute with his employer and bought into a competitor's snowball stand. Mansfield started giving snowballs away, but Burnett was destined for law school and he gently persuaded Mansfield to cease and desist. On the left is Burnett's sister Susie, author of a memoir about the family's summers on the beach called "When the Moon Stood Still." (Courtesy of Gilbert Burnett.)

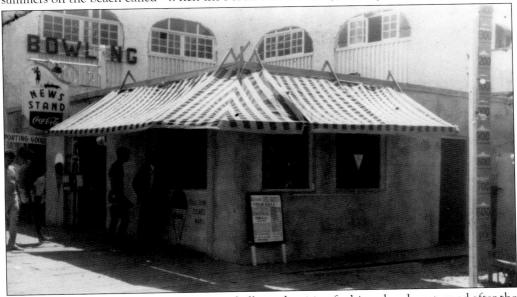

Burnett had a much bigger and better snowball stand waiting for him when he returned after the war. It was built by Coca-Cola and was a huge improvement over the counter and umbrella he had before he left. But, he said, his postwar snowball career only lasted a few summers before he set off to do other things, such as build a boat, start a business, and somewhere down the line, go to law school. Notice the old bowling alley behind the stand and the wooden boards in front, back when the boardwalk was actually made of boards. (Courtesy of Gilbert Burnett.)

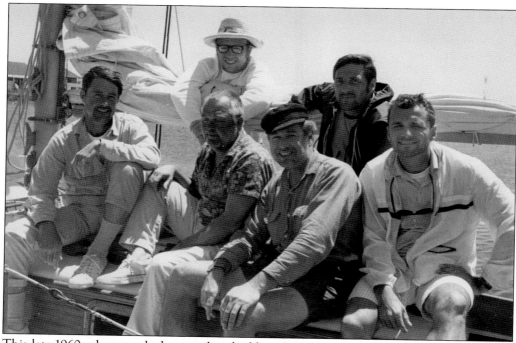

This late-1960s photograph shows sailing buddies aboard a cutter-rig sailboat launching from Carolina Beach bound for the Bahamas. Gil Burnett, on the left, tells stories of the sea, rough weather, and the Bermuda Triangle, along with colorful tales about his shipmates, all of them connected in some way to Carolina Beach. Burnett survived it all to become a federal district court judge. (Courtesy of Gilbert Burnett.)

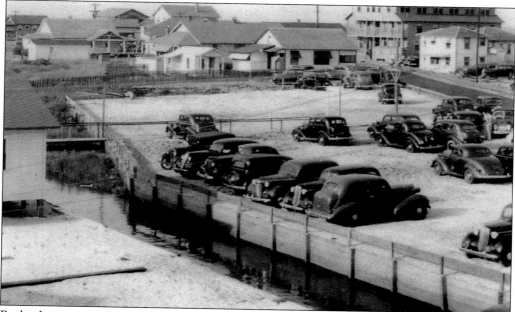

Back when cars and paved roads were both relatively new, it was a lot easier to find a parking space near the boardwalk. (Courtesy of the Federal Point History Center.)

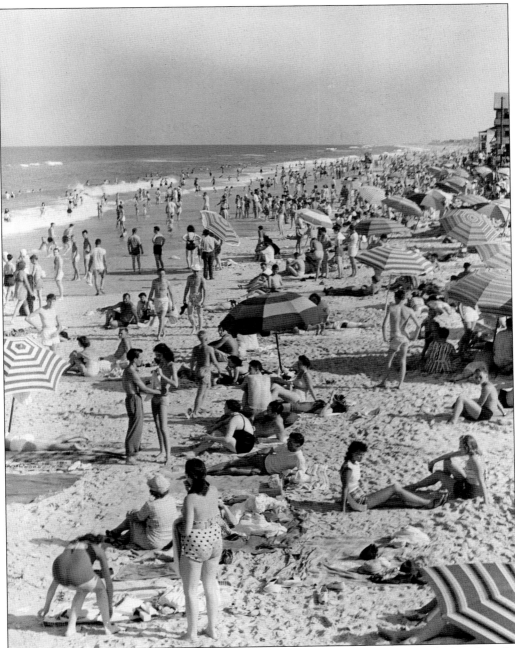

Photographer Hugh Morton took this shot of the prolific crowds that flocked to the beach in the 1940s and 1950s. Holiday weekends still look a whole lot like this. (Courtesy of the University of North Carolina Wilson Library, Hugh Morton Collection.)

Bathing suits in the 1930s had evolved to a middle ground somewhere between the woolen neck-to-ankle affairs of previous decades and the string bikinis of today. Bathhouses rented bathing suits and towels by the day. Women were just beginning to swim in the 1930s, as opposed to clinging helplessly to lifelines that were firmly staked in the sand. (Courtesy of the New Hanover Library, Louis T. Moore Collection.)

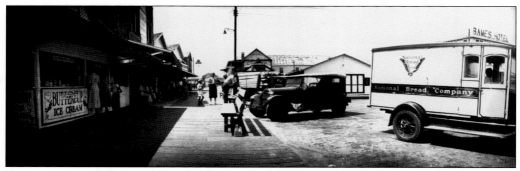

Here is a view of the main boardwalk area in the 1930s, with a concession stand, a vintage automobile, and a delivery truck. (Courtesy of the New Hanover County Public Library, Louis T. Moore Collection.)

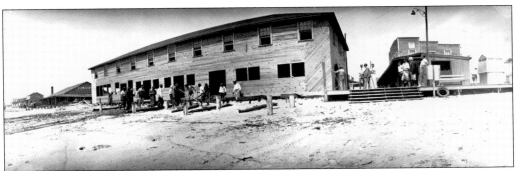

Construction in the boardwalk area was a Works Progress Administration (WPA) project. Pres. Franklin Delano Roosevelt created eight million WPA jobs from 1935 to 1943 to alleviate unemployment following the Great Depression and to undertake numerous public works projects as part of the New Deal. (Courtesy of the New Hanover Library, Louis T. Moore Collection.)

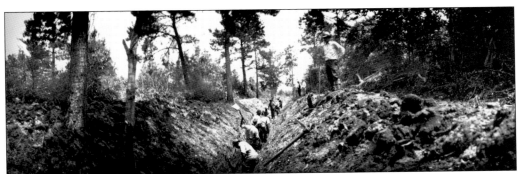

Another WPA project was the Henniker drainage ditch, dug through property belonging to George C. Henniker (1876–1955). It was created to channel a series of tributaries from Carolina Beach Lake to the Cape Fear River, and it runs down the north side of Newton Cemetery on Dow Road. Most of it lies in the so-called "buffer zone," created in consideration of the Military Ocean Terminal at Sunny Point across the river in Brunswick County, the nation's largest nuclear weapons cache. The buffer zone is federally owned property that runs the entire west side of the island. (Courtesy of the New Hanover Library, Louis T. Moore Collection.)

In the late 1940s, Daisy Cumber (right) and Hazel King pose for the camera with the Fisherman's Steel Pier in the background. (Courtesy of Judy Moore.)

Little Kimberly Moore was six years old in this 1962 photograph. Here again, the Steel Pier looms large over her enormous sandbox. (Courtesy of Judy Moore.)

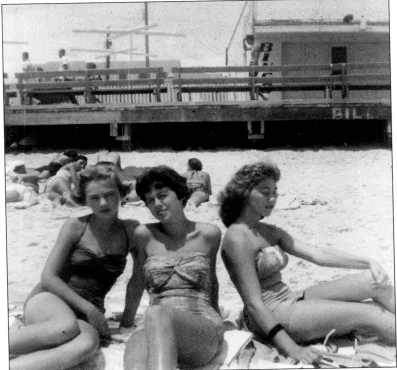

From left to right, Brenda Fesperman, Doris Shoe, and Carolyn Moose soak up the sun in the 1950s. Doris Shoe married into the Bame family that owned and operated Bame's Hotel. (Courtesy of Doris Bame.)

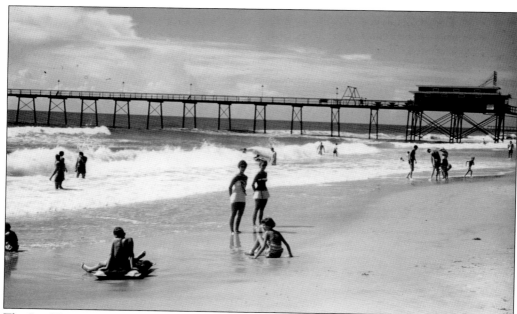

The Steel Pier was once the centerpiece of Carolina Beach. It featured the Skyliner, a chair lift that carried spectators to the end of the pier. Built in 1953, the Steel Pier was 1,000 feet long and had a poolroom and a barbershop. Hurricane Hazel in 1954 shaved off about 200 feet, and subsequent storms inflicted further damage. It was demolished in 1975. (Courtesy of Charles Greene.)

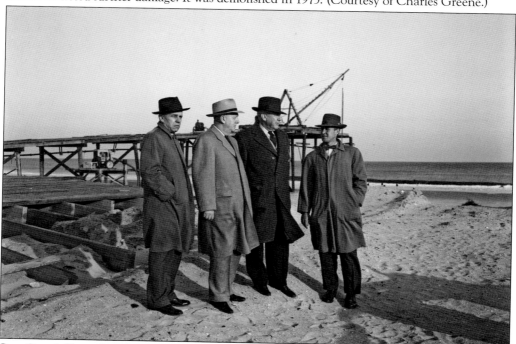

Sen. Sam J. Ervin Jr., along with three unidentified men, toured the coast in the aftermath of Hurricane Hazel to survey the damage caused by the storm. (Courtesy of the University of North Carolina Wilson Library, Hugh Morton Collection.)

The pier at the north end was built in 1946 and became known, most logically, as North End Pier. It was demolished by Hurricane Hazel in 1954 and promptly rebuilt. Subsequent storms did subsequent damage, and Freddy Phelps rebuilt the pier in 1979. Hurricane Diane lopped off 500 feet (1984), Hugo took off 400 feet (1989), Bertha demolished 200 feet (1996), Fran took down the whole thing (1996), and Bonnie lopped off 45 feet (1998). Despite countless setbacks, this pier continues to be a major attraction, one of only two piers still standing on Pleasure Island. The other is at Kure Beach. (Courtesy of the University of North Carolina Wilson Library, Hugh Morton Collection.)

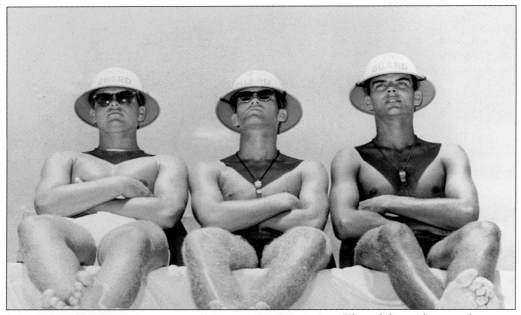

Three lifeguards around 1957 are, from left to right, Charlie Greene, Byron Moore, and Dickie Wolfe. (Courtesy of Judy Moore.)

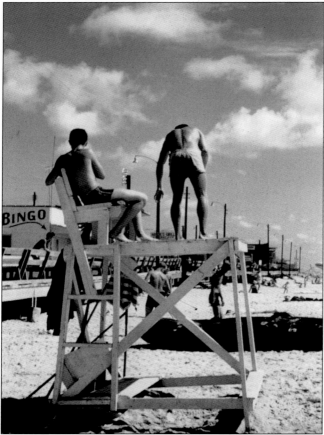

Lifeguards during the 1950s were mostly male and had a bird's-eye view of all the lovely young ladies sunbathing on the beach. (Courtesy of Charles Greene.)

Oftentimes the lifeguards did not have far to look. The girls either spread out their blankets and towels at the foot of the lifeguard stand or found a perch on the stand itself. (Courtesy of the North Carolina State Archives.)

Some of the girls the lifeguards kept an eye on were, from left to right, Jackie Greene, Barbara Hewitt, Pearl Winner, and Sylvia Fountain, shown around 1952. (Courtesy of Charles Greene.)

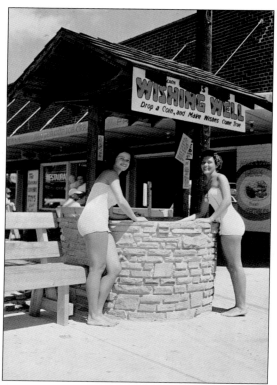

Norma (left) and Frances Best (right) must have gone to the Wishing Well in the 1950s to wish for their own bathing suit shop on the boardwalk. They got their wish. (Courtesy of Doris Bame.)

Contestants for the 1946 Miss North Carolina Pageant enjoyed a photograph shoot and an extended stay on Carolina Beach. The finalists were, from left to right, Helen Cameron, Della Frances Perry, Catherine Nicholls, Marjorie Dunn, Ann Gillikin, Mary Jarman, Hilma Chadwick, and Peggy Ann Terry. (Courtesy of the University of North Carolina Wilson Library, Hugh Morton Collection.)

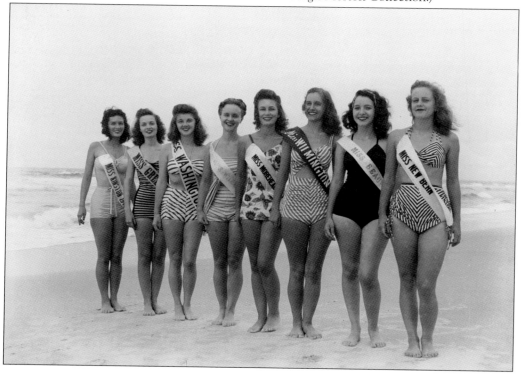

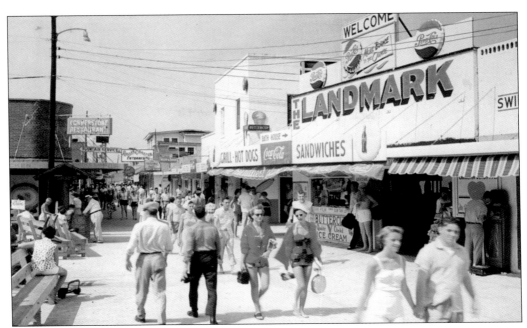

Cliff Smith's shop on the boardwalk was definitely a landmark. He sold everything from sandwiches to beach towels in a prime location adjacent to the fabled Wishing Well. (Courtesy of Elaine Henson.)

Brenda Ames owned and operated the Landmark in its later years. The Landmark closed in 2005. (Courtesy of the New Hanover County Public Library, *Star-News* Image Archive.)

H.L. Britt opened Britt's Donuts in 1939, and the shop is still in operation today. His recipe was always a closely guarded family secret until it was passed on to Bobby Nivens, an employee who bought the place in 1974. It is one of the most long-lived and famous Carolina Beach establishments, and like most boardwalk shops, it opens Memorial Day and closes Labor Day. To many local minds, the start of beach season is the start of donut season. (Courtesy of Britt's Donuts.)

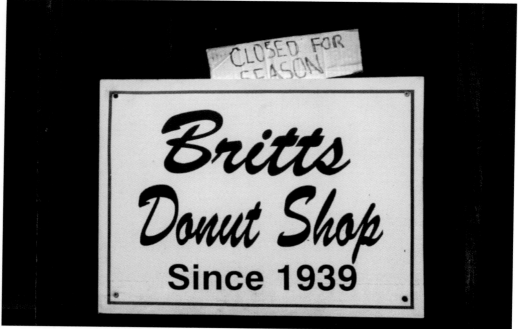

Most of the boardwalk merchants open for weekends only several months prior to Memorial Day and several months after Labor Day, but not Britt's Donuts. Owner Bobby Nivens claims that is one thing that makes his donuts so special. (Courtesy of Britt's Donuts.)

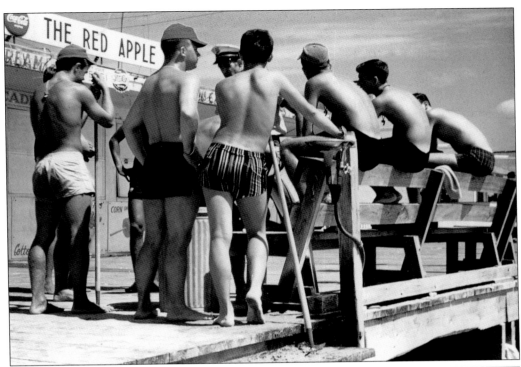

The long-gone Red Apple has been described as "the full Coney Island," with dogs, burgers, french fries, buttered corn on the cob, cotton candy, candied apples, and whatever else might appeal to this 1957 group of lifeguards. As a visual treat that attracted spectators, the shop had a machine that pulled saltwater taffy. (Courtesy of Charles Greene.)

Hanging around at the Red Apple was one of the things lifeguards Lank Lancaster (right) and Bernard Bledsoe did best. (Courtesy of Charles Greene.)

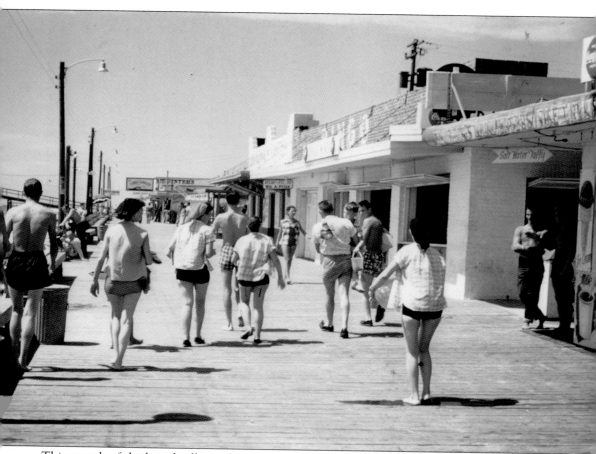

This stretch of the boardwalk ran from the Red Apple past the Bingo Parlor on the way to the entrance to the Steel Pier at the south end. (Courtesy of Charles Greene.)

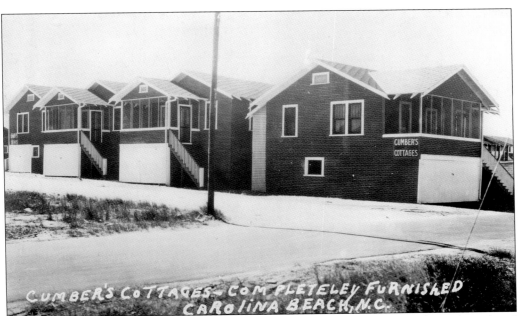

Cumber's Cottages were all in a line at the intersection of South Lake Park Boulevard and Atlanta Avenue, across the street from Carolina Beach Lake. A car wash now stands in place of the cottages. (Courtesy of Judy Moore.)

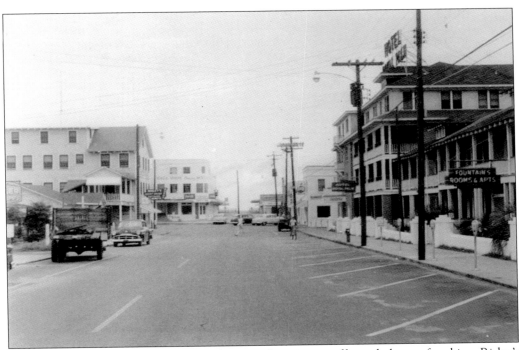

In what must have been a winter scene because there is no traffic and plenty of parking, Risley's Ocean Plaza and Hotel Royal Palm were quiet in the off season. (Courtesy of Charles Greene.)

This was the former Harper House, the beach residence of the illustrious Capt. John Harper; it was demolished in the 1970s. Charles Greene's family ran Greene's Rooms and Apartments. Today, McDonald's occupies this prime piece of real estate. (Courtesy of Charles Greene.)

Jack and Naomi Greene are shown with son Charlie, sometimes also known as "Tommy," around 1954. (Courtesy of Charles Greene.)

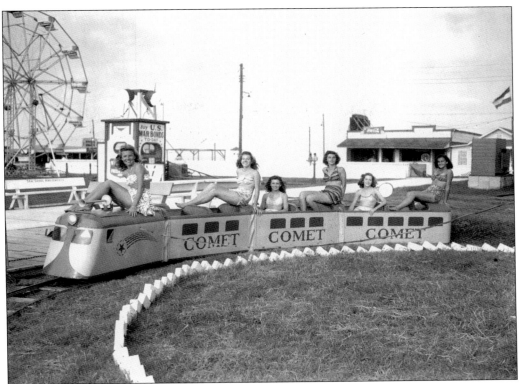

Beautiful, smiling young girls waved at the camera from aboard the "Comet." Notice the sign in the background, "Buy war bonds." (Courtesy of the North Carolina State Archives.)

Hazel was a category four hurricane that struck on the morning of October 15, 1954, during a full-moon high tide. October has one of the highest astronomical tides of the year, and duck hunters call it the "marsh hen tide" because high water flushes waterfowl out of marsh grasses. (Courtesy of the Federal Point History Center.)

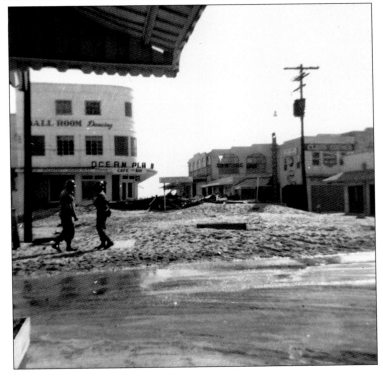

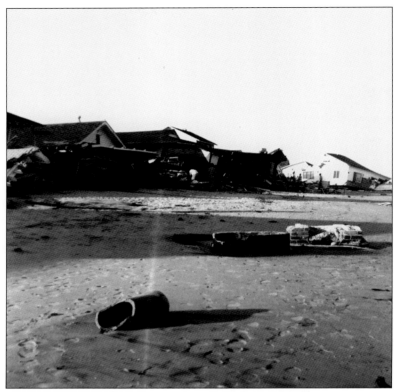

Hazel followed on the heels of Carol (August 30, 1954) and Edna (September 10, 1954), so that the ground was already saturated and the inland waterways overfilled. Both of the earlier hurricanes passed a few miles offshore through the Cape Fear region and inflicted minor damage along the Outer Banks to the north. (Courtesy of the Federal Point History Center.)

Hurricane Hazel plotted a new route for her march to the New England states, but even before leaving the Caribbean, she killed an estimated 1,000 Haitians with flooding and massive landslides. Heading north, she made landfall at Little River, South Carolina, and the nearby Brunswick County beaches took a direct hit. She sent surge levels up to 18 feet over Brunswick beaches, sweeping some islands completely clean. She not only carried away homes and structures never to be seen again but also flattened the dunes they would have been sitting on or behind. With all roads washed away or under several feet of sand and all trees and vegetation obliterated, it was tricky for many homeowners to say for sure where their real estate used to be. (Courtesy of the Federal Point History Center.)

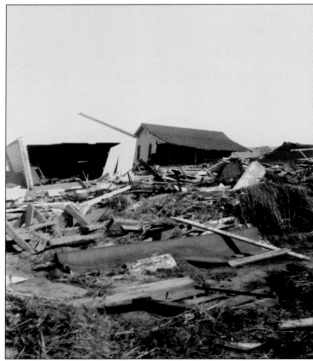

The Carolina Beach boardwalk was stripped of its boards, and Hazel piled the surplus lumber in the streets, layered in with many feet of sand. She sent huge waves crashing through downtown streets, busting out windows and gutting shops. While the waves undermined foundations, the winds battered structures. The National Guard arrived to prevent looting and to search for victims. The Fort Fisher Pier went down in the storm, never to be rebuilt. (Courtesy of the Federal Point History Center.)

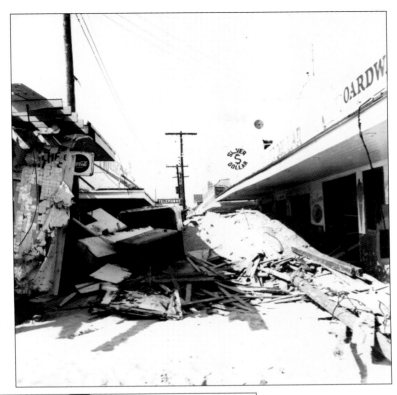

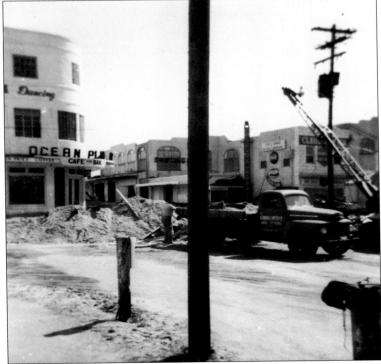

Many of the boardwalk businesses remained standing after the storm, while many others were reduced to large piles of rubble. By the time Hazel left town, Carolina Beach had 14 blocks of downtown streets underwater, 362 buildings destroyed, 288 structures with major damage, and an estimated $17 million worth of damages. (Courtesy of the Federal Point History Center.)

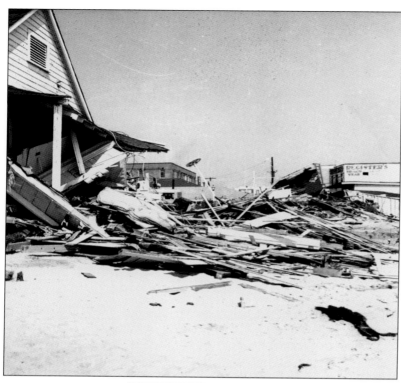

All told, 19 people in North Carolina were killed, 200 injured, 15,000 structures destroyed, and 39,000 damaged, all at an estimated $136 million in property losses. The National Hurricane Center ranks Hazel among the top 25 deadliest, costliest, and most intense hurricanes in history. (Courtesy of the Federal Point History Center.)

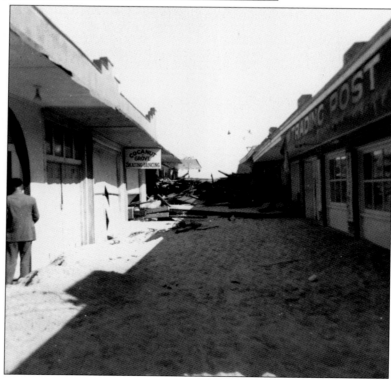

When the waters at last receded from the hardest-hit areas of the Lower Cape Fear, in many cases, it was like starting over with a clean slate. Structures that were rebuilt were made stronger and more wind- and water-resistant. The bricks from the demolished Breakers Hotel in Wilmington Beach were used to stabilize Fort Fisher's shoreline, always an area that suffers from serious and ongoing erosion problems. (Courtesy of the Federal Point History Center.)

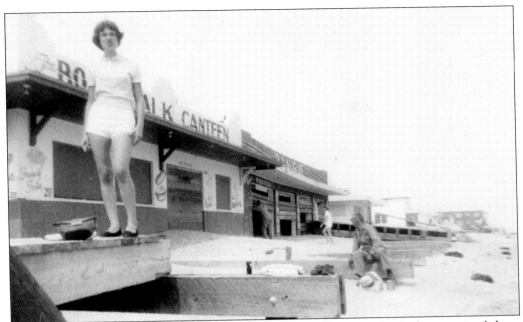

After the storm, Doris Shoe walked to the end of the boardwalk—a spot that had not previously been the end of the boardwalk. Three more hurricanes arrived for the 1955 season: Connie, Diane, and Ione, all of them bad but none of them nearly quite so memorable. In 2007, Oak Island, a Brunswick County beach, erected a historical marker commemorating Hazel. (Courtesy of Doris Bame.)

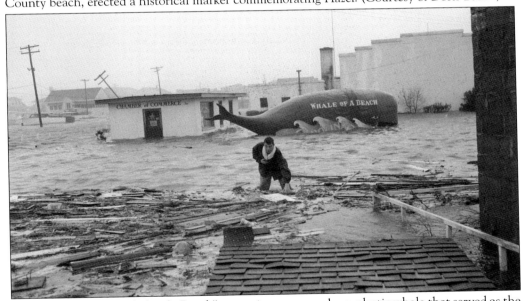

"Carolina Beach: A Whale of a Beach" was written across a huge plastic whale that served as the island's ambassador. Pretty girls in bathing suits waved at crowds from their perch atop the whale in the Azalea Festival Parade, and when it was not parading, it was prominently displayed for all to see near the municipal marina. Photographer Hugh Morton caught this shot of the whale as it floated out to sea on the flood waters of Hurricane Hazel. (Courtesy of the University of North Carolina Wilson Library, Hugh Morton Collection.)

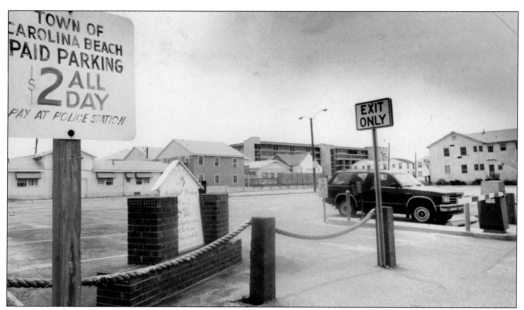

Once upon a time, people could park all day for $2 in the municipal lot, as shown in this 1986 photograph. Paying at the police station was not a terrible inconvenience, since town hall was at that time adjacent to the beach parking. (Courtesy of the New Hanover County Public Library, *Star-News* Image Archive.)

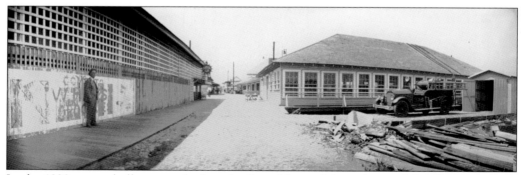

In the 1930s, town hall was on the boardwalk and housed the police and fire departments. It also served as a makeshift schoolhouse for kindergarten through the sixth grade. That original town hall is shown on the right in this photograph with a fire truck parked in front. The dance pavilion is on the left. Both buildings were casualties of the 1940 boardwalk fire. (Courtesy of the New Hanover County Public Library, Louis T. Moore Collection.)

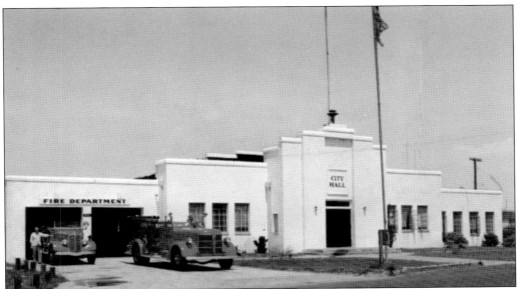

The next town hall sat on land that is now the municipal parking lot, between the marina and the boardwalk. It was partially financed by WPA funds and opened in 1942 with an 800-seat auditorium, police and fire departments, jails for white and black people, a kitchen, a rec room, and, by 1950, a library. Its location put it directly in the paths of floods and hurricanes, so the town's emergency personnel often had to be evacuated. The facility was demolished in 1991, and the streets around it were rerouted. (Courtesy of Elaine Henson.)

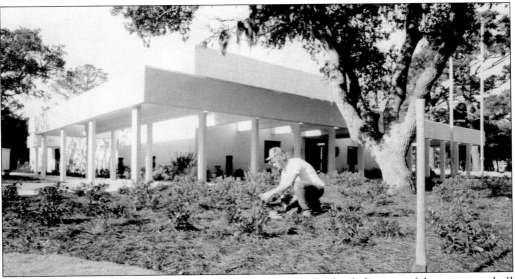

Landscaper John Marshburn planted bushes in preparation for the dedication of the new town hall in December 1990. The new facility was formerly the old Blockade-Runner Museum, located on slightly higher ground on North Lake Park Boulevard. Today, it houses the chamber of commerce and the municipal government. The police department is located in a recent addition on the north side. The fire department moved to a facility on Dow Road. The Federal Point History Center opened in a small building adjacent to the new town hall. (Courtesy of the New Hanover County Public Library, *Star-News* Image Archive.)

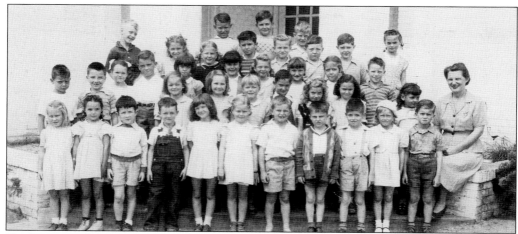

Kindergarten through the third grade in the 1937–1938 school year were the last to camp out in the old town hall on the boardwalk before a school was built. Carolina Beach School got its start at the beginning of the 20th century on the banks of the Cape Fear River in a run-down building that burned in 1916. For several years, children were bussed to Myrtle Grove School until beach residents were able to secure the use of two rooms in the old town hall on the boardwalk. Mae McFarland taught kindergarten through the third grade, and Madge Woods taught fourth through sixth grades. (Courtesy of Doris Bame.)

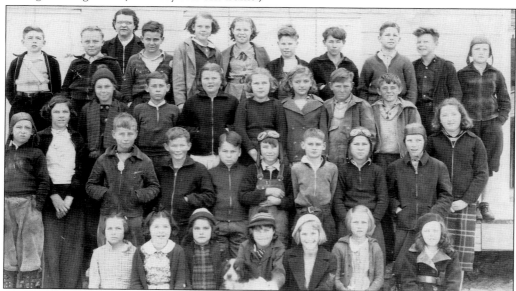

The fourth-, fifth-, and sixth-graders of 1937–1938 attended school in the old town hall. Pictured are, from left to right, (first row) Helen Lewis, Margaret Jordan, Evelyn Bender, Dorothy Gary, Gladys Davis, unidentified, and Ann Coleman; (second row) Billy Dew, Iona May Davis, Robert Strickland, Hugh Kelley, Jimmy Lewis, C.F. Lewis, Robert Watters, Harold Ludwig, and Peale Brittain; (third row) Anna Lee Lewis, Ryder Lewis, Laurice Hickman, Juanita Bame, Catharine Roseman, two unidentified, and Colleen Clark; (fourth row) Mac Biddle, Bobby Harlow, Charles Hewett, unidentified, Betty Gray, James Lewis, Fred Dew, Richard Wooten, and Martin Fields. Behind the students is principal Madge Woods, who also taught these grades. (Courtesy of Doris Bame.)

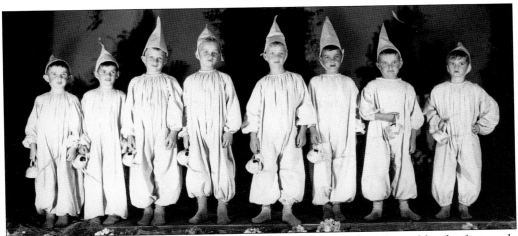

At the new Carolina Beach School, "Raindrops" was the musical performed by the first-grade class of 1946. Their costumes were supposed to resemble raindrops, and the children sang a little raindrops song. (Courtesy of Judy Moore.)

The current schoolhouse has been added onto through the years. An increasing number of year-round residents created a demand for expansion, and work began in 1942 for three new classrooms, a principal's office, a book closet, and a teacher's restroom. In 1953, three more classrooms were added, an auditorium was built, and a new kitchen area started serving hot lunches. In 1975, the Denning T. Butcher Primary Wing was built and named in honor of a former principal. The school was struck by lightning in 1982, and some classes were moved to a nearby church. Other additions and renovations continued throughout the late 1980s. (Courtesy of Federal Point History Center.)

This church basketball team was part of an interdenominational league comprised of Presbyterians, Methodists, Baptists, Lutherans, and Catholics in 1957. The high school was in Wilmington, so for many years, local churches sponsored athletic events for teens. (Courtesy of Judy Moore.)

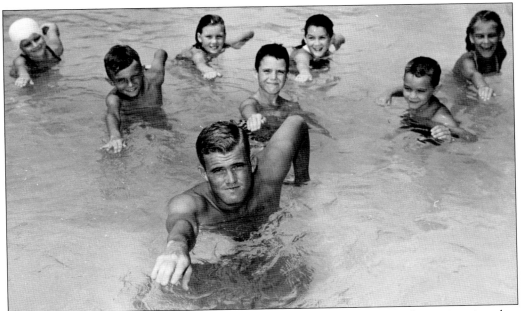

Byron Moore was Carolina Beach's first recreation director in 1959. He taught a swimming class at the Nel-El Motel, and his official duties also included coaching softball. He spent half-days working with kids and half-days lifeguarding. (Courtesy of Judy Moore.)

In this *Wilmington Star-News* photograph, it would appear that the Ferris wheel is arriving for the summer season fully assembled on the backs of two tractor-trailers. Considering traffic lights, power lines, and Highway Safety Administration guidelines, this would have been totally impossible. The very cryptic newspaper caption on this shot reads simply, "Ferris wheel on street, June 10, 1981." (Courtesy of the New Hanover County Public Library, *Star-News* Image Archive.)

Sunshine Amusements had a roller coaster during the 1980s. (Courtesy of the New Hanover County Public Library, *Star-News* Image Archive.)

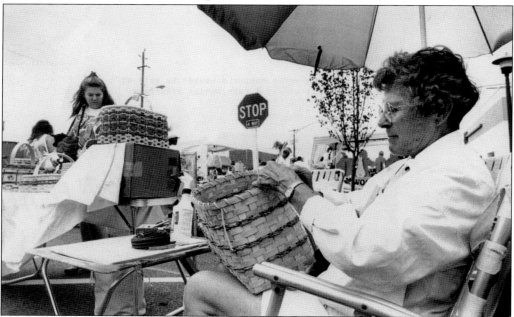

Just like the businesses and amusements, festivals seem to come and go on Pleasure Island. In this photograph, Emily Barber makes a basket for the 1994 Pleasure Island Springfest, an event that no longer exists today. Members of the Merchant's Association staged Springfest throughout the 1980s and early 1990s, as well as a big Halloween festival that took over most of Canal Drive during roughly the same years. (Courtesy of the New Hanover County Public Library, *Star-News* Image Archive.)

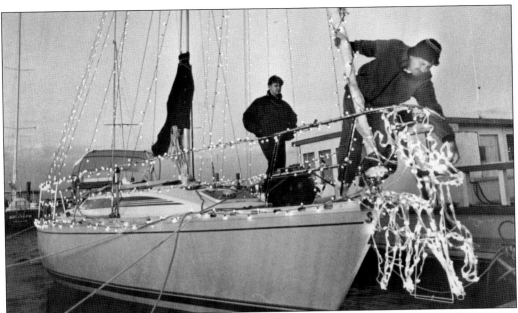

Ron Johnson prepared for his first Holiday Flotilla in 1992, an annual tradition that so far remains intact. The "Island of Lights" name came from this and other holiday events, including a Christmas parade that lights up Lake Park Boulevard every year. Bruce Freeman helped to organize some of the early Christmas parades with two Santas throwing candy from the back of a fire truck. One Santa was black, and the other was white. (Courtesy of the New Hanover County Public Library, *Star-News* Image Archive.)

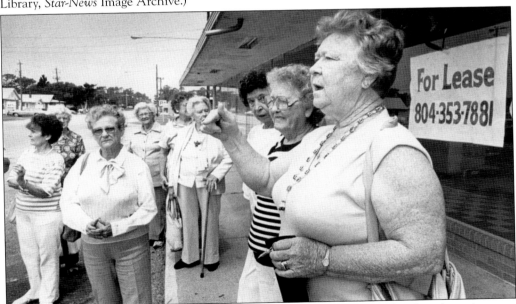

Marie Gaily stood outside the recently closed A&P on Cape Fear Boulevard and airs her grievances about the store's closure in 1987. The back of the building that houses the Sea Merchant still has big letters, "Super A&P Market." An earlier A&P was adjacent to the boardwalk area. (Courtesy of the New Hanover County Public Library, *Star-News* Image Archive.)

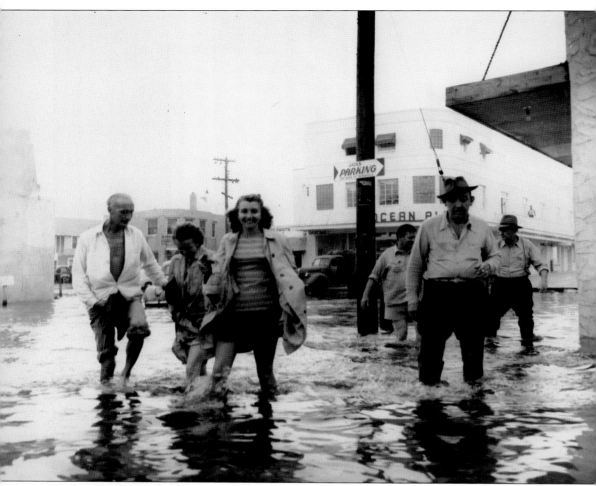

The big flood of 1946 was not accompanied by a hurricane. As they say in forensic circles, it acted alone, a freak storm surge that engulfed local businesses in several feet of water for several days. Seen here are, from left to right, Mr. Pratt, Annie Morton (the postmistress), Emily Wysong, unidentified, Mr. Woodcock, and A.P. Pea wading down Lake Park Boulevard. (Courtesy of Charles Greene.)

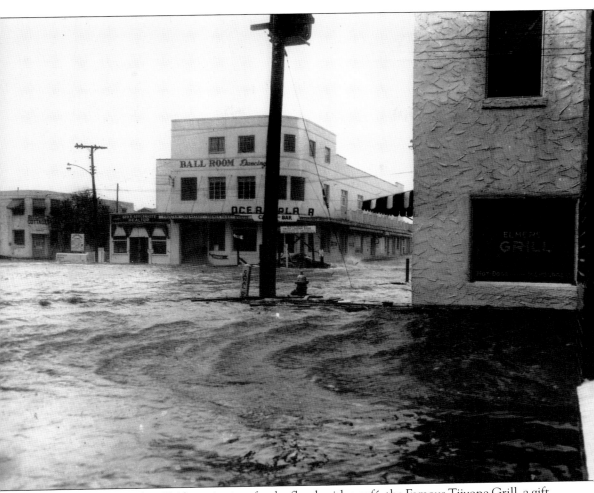

Ocean Plaza opened in 1946, just in time for the flood, with a café, the Famous Tijuana Grill, a gift shop, and a bathhouse on the ground floor. The second floor was a ballroom, and the third floor was an apartment. Big names came to play the ballroom—Fats Domino, Chuck Berry, Bo Didley, and Jerry Lee Lewis. The building was torn down in 2006. (Courtesy of Charles Greene.)

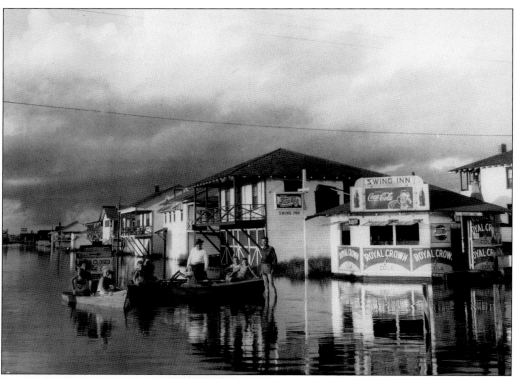

The streets and businesses around Carolina Beach Lake always are the hardest hit during high-water events, and in this shot, the only traffic on Lake Park Boulevard is boat traffic. (Courtesy of Charles Greene.)

Wilmington Beach was a slice of oceanfront development wedged between Carolina and Kure Beach. Officially, it has been annexed by Carolina Beach, but the name still occasionally appears on maps and brochures. (Courtesy of the New Hanover County Public Library, *Star-News* Image Archive.)

Walter Winner built Center Pier at Wilmington Beach in 1947. Most of the pier went down in 1995 during Hurricanes Bertha and Fran. Thereafter, the Ocean Grill Restaurant was built at the base of the pier's much-abbreviated remnants, and the ever-popular Tiki Bar now stands at the pier's new end. (Courtesy of Jay Winner.)

Wilmington Beach had two locally famous residents during the 1920s and 1930s. Percy Wells and James "Foxy" Howard built one of the first theaters in the state, starting out in 1906 with a tent at 205 North Front Street in Wilmington. It had a wooden facade to create the illusion of a building, and in 1912, the enterprise developed into the Bijou Theater. Both men had cottages on the beach and brought their families to stay through the summertime. (Courtesy of Elaine Henson.)

Percy Wells (known as "the Great Percino" during his circus tightrope walker career) entertained Grandmother Fisher (left) and Grandmother Wells at his beach cottage in 1936. His wife, Alice Fisher Wells, sometimes played the piano and sang at the Bijou between films, while he projected images onto the screen that illustrated the lyrics. (Courtesy of Elaine Henson.)

Little Foxy Howard (left) and Rich Wells are seen playing together in 1923 on Wilmington Beach. By that time, their fathers had made their fortunes beginning with a 600-seat theater, later adding 200 seats in the balcony for black patrons and a mammoth Seeburg pipe organ. The Bijou closed its doors in 1956 and was torn down in 1963. Their fathers sold their other movie theaters (the Carolina, Grand, Roya, and Bijou) in 1933, so the boys were unable to look forward to getting into the family business. (Courtesy of Elaine Henson.)

Three

KURE BEACH

Hans A. and Ellen Mueller Kure (the "e" is pronounced) got their start on Carolina Beach, not the beach that bears their name, soon after they came to these shores from Denmark some time around 1879. At the time of the big boardwalk fire of 1910 on Carolina Beach, they had a bowling alley, a billiard hall, a trap shoot place, a bar, a family grocery, hobbyhorses, and Smith's Cottages. They bought land a few miles down the coast and refocused their energies on creating a new resort starting from scratch. Their five children were William "Cap," Hans Anderson "H.A.," Lawrence Christian "L.C.," Elene, and Andrew "Bubba." (Courtesy of the Federal Point History Center.)

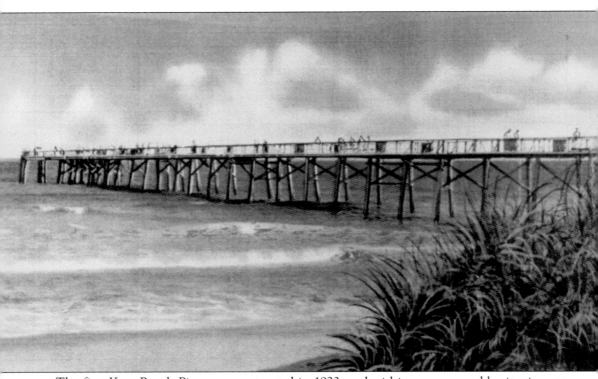

The first Kure Beach Pier was constructed in 1923, and within a year, wood-boring insects consumed it to the point of collapse. L.C. Kure was inspired to develop concrete pilings with an inner core of steel. The new pier was 234 feet long, 32 feet wide, and lighted from one end to the other for night fishing. It had a small cold drink stand and the usual ticket office. The Kure Beach Development Company, comprised mostly of members of the Kure family, built a waterworks and then a road. The road construction company was hauling rock from Lillington when it noticed coquina shell lining the beach down at Fort Fisher. Mining that shell would almost certainly cause substantial erosion at the beach, but the town council agreed to use it anyway, setting another environmental catastrophe in motion. (Courtesy of the Federal Point History Center.)

Betty and Andrew Kure had a beach cottage around 1945 in Kure Beach. It did not officially become Kure Beach until it was incorporated in 1947, but people already called it by that name. (Courtesy of Jay Winner.)

An aerial view of Kure Beach today would not look much different. One new addition at the fishing pier is a big sign put up by the current owner that reads, "Man, you should have been here last week." (Courtesy of the Federal Point History Center.)

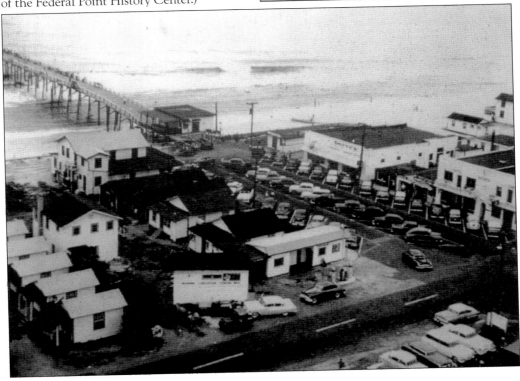

Born in 1897, Walter Winner was a brother of Carl and Martin and is shown here in 1945 with his wife, Cele, and their son Jay. (Courtesy of Jay Winner.)

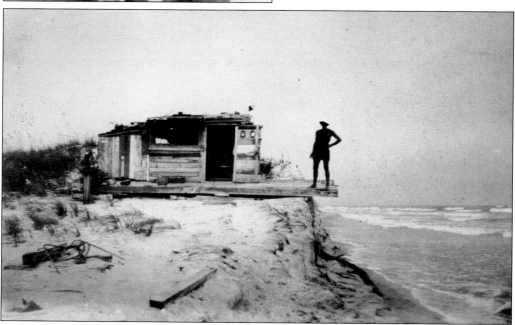

In this 1920 photograph, Walter Winner demonstrated the ongoing problem he had with constructing oceanfront structures. In no time flat, a fishing shack he had built a good distance from the high-tide mark was suddenly teetering on the brink. (Courtesy of the New Hanover County Library, Robert M. Fales Collection.)

Walter Winner built a waterfront house in 1921, and for many years, he operated a store and a bathhouse on the bottom level. He moved the house back from the beach twice as the ocean encroached and then, in 1949, moved it to another location entirely in Kure Beach. (Courtesy of Jay Winner.)

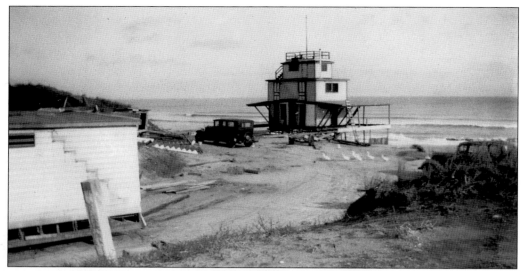

This photograph shows the house moving in 1947 to another short retreat from the oceanfront before moving to higher ground. (Courtesy of Jay Winner.)

Jay Winner and his mother, Lucille, stand on the front steps of their relocated residence. The pet squirrel on Jay's shoulder was named Frisky. (Courtesy of Jay Winner.)

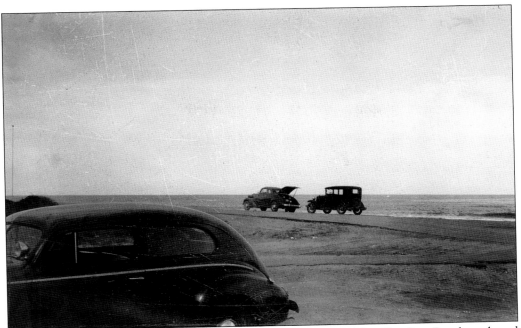

Walter Winner took visitors driving on the beach and fishing. After Carolina Beach outlawed car racing on the beach, Kure Beach became the place to do it. (Courtesy of Jay Winner.)

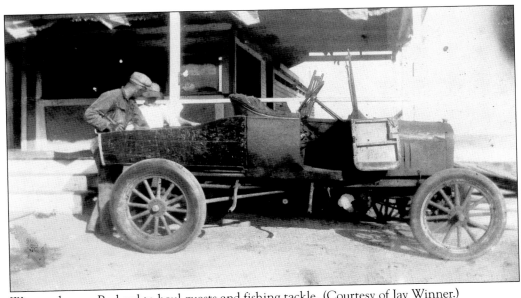

Winner drove a Packard to haul guests and fishing tackle. (Courtesy of Jay Winner.)

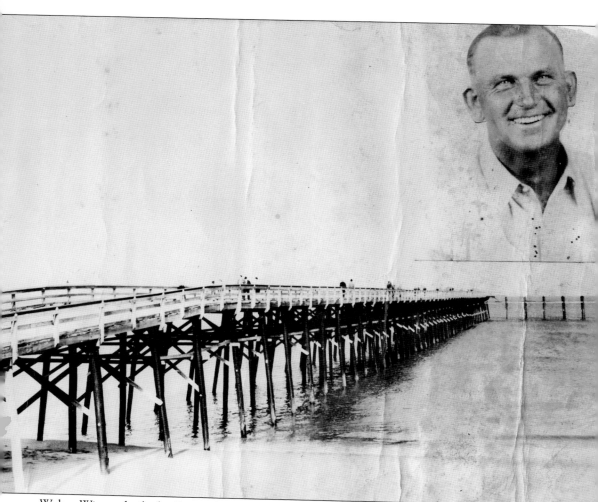

Walter Winner built the Fort Fisher Pier in 1938 over the ruins of the Civil War shipwreck the *Modern Greece*. The pier went down in Hurricane Hazel in 1954 and was not rebuilt. (Courtesy of Jay Winner.)

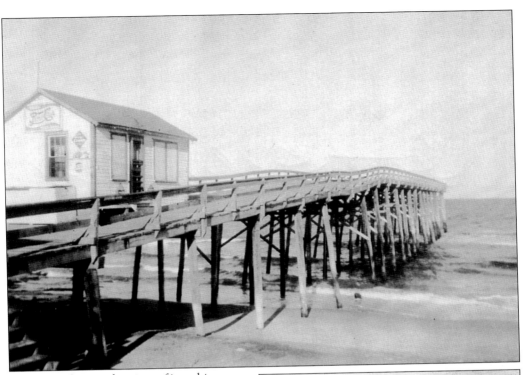

Winner's advertised a pier café, parking, ice water, all-wool bathing suits, fishing, bathing, and boating. (Courtesy of the Federal Point History Center.)

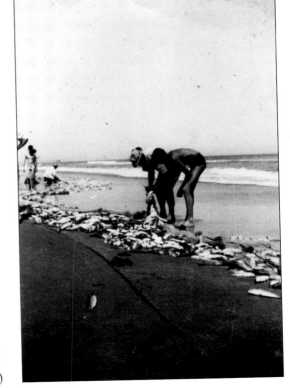

Net fishing for mullet is not something one sees much of anymore, and actually eating mullet has completely gone out of style. Now the Got-Em-On Live Bait Club, headquartered in Carolina Beach, preserves the practice of catching live bait with nets and mostly snags menhaden and mullet minnows. (Courtesy of Jay Winner.)

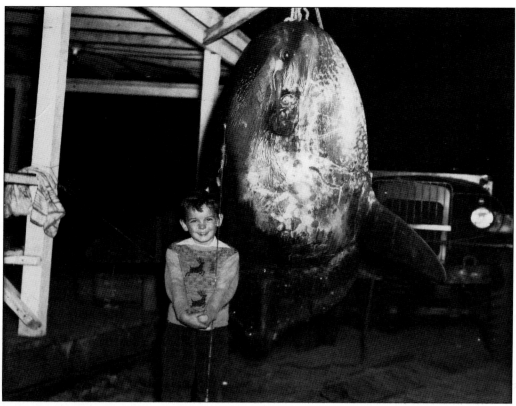

In this shot, Walter Winner positioned his young son Jay, along with his spindly little fishing rod, in front of a whopping 500-pound sunfish. Now there is a fish story if ever there was one. The ocean sunfish is also known as mola-mola and is not typical of what people think of as game fish. It lurks near the surface, feeding on jellyfish, and can weigh up to two tons. (Courtesy of Jay Winner.)

A slightly more believable fish story is shown here, with three-year-old Jay Winner catching a porcupine fish a little closer to his own size. (Courtesy of Jay Winner.)

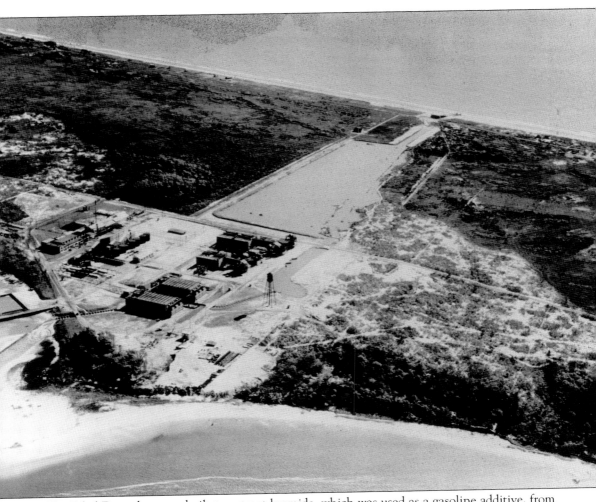

The Ethyl-Dow plant was built to extract bromide, which was used as a gasoline additive, from ocean water. The plant created jobs and boosted the development effort in Kure Beach enormously. During World War II, it allegedly became a target for missiles launched by offshore German submarines, which widely missed the mark and landed harmlessly in the Cape Fear River. Coastal residents were told that when the lights went out at the shipyard, it was the real thing. On the night the missiles were launched at Ethyl-Dow, the lights went out at the shipyard in Wilmington, and the panic spread down the coast. Coastal residents often saw tankers burning offshore and oil slicks washing up on shore. (Courtesy of the Federal Point History Center.)

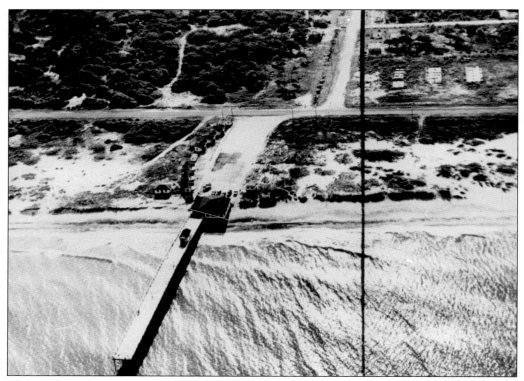

Another aerial view shows the intake pipe of the massive Ethyl-Dow complex. Remnants of the old plant survive in the so-called buffer zone. (Courtesy of the Federal Point History Center.)

Airmen and their families have always relaxed and had fun on Kure Beach, as seen in this 1957 photograph. The Air Force maintains a recreational center on the river side of the island, just a short walk to the beach, with a cluster of houses, a riverfront snack bar, and the North Carolina Military History Museum, housing a collection of vintage planes and vehicles, along with old uniforms, medals, portraits, pictures, and weapons. (Courtesy of Charles Greene.)

This aerial view of what is now the Air Force Recreational Center was probably taken during the 1960s. About 40,000 troops were stationed here during the 1940s, and the facility continued to operate as a base until 1988, when the Air Force discontinued active use. It remains a satellite facility of Seymour Johnson Air Force Base in Goldsboro. Note the golf ball–type radar, which is no longer on the premises. (Courtesy of the National Guard Training Center.)

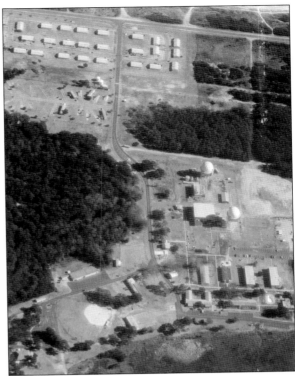

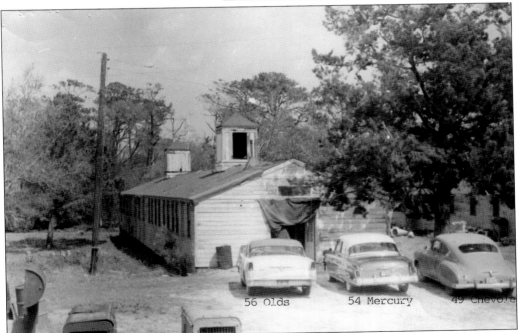

MARS is a military-affiliated radio station, and the 701st Aircraft Control and Warning Squadron operated this one. Parked in front are a 1956 Olds, a 1954 Mercury, and a 1949 Chevy. (Courtesy of the National Guard Training Center.)

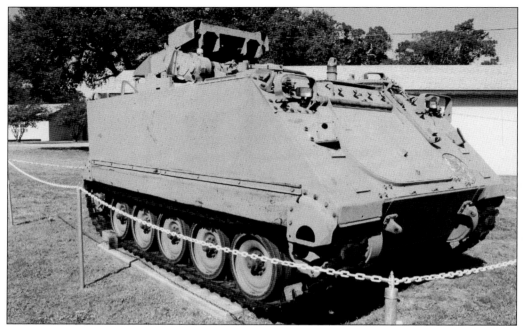

The North Carolina Military History Museum is on the recreational center's grounds and maintains an arsenal of tanks, guns, and a helicopter clustered on the lawn around the building. This tank is known as a 1-1-3 personnel carrier and can carry six to eight people, not very comfortably. It was built in the 1980s and served in the Gulf War and Desert Storm. (Courtesy of the North Carolina Military History Museum.)

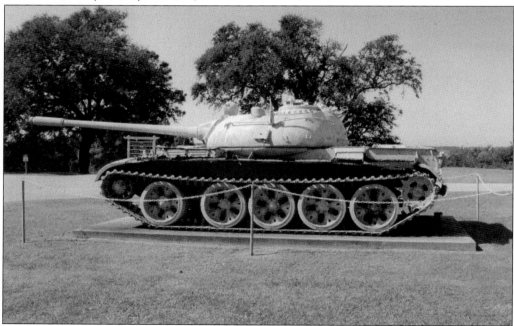

This Soviet tank is a T-50 and came home with US troops from the Gulf War. (Courtesy of the North Carolina Military History Museum.)

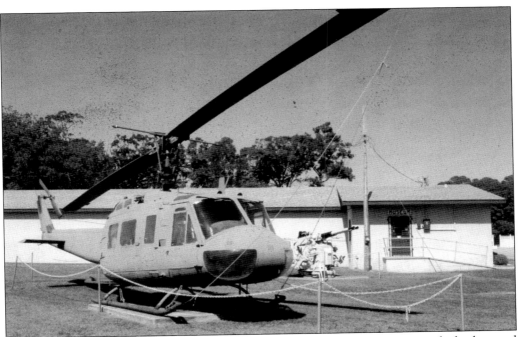

The helicopter in the collection is a Huey from the Vietnam era. The museum is in the background of this photograph, formerly a two-lane bowling alley converted to its present use in 1991. It is only open on weekends. (Courtesy of the North Carolina Military History Museum.)

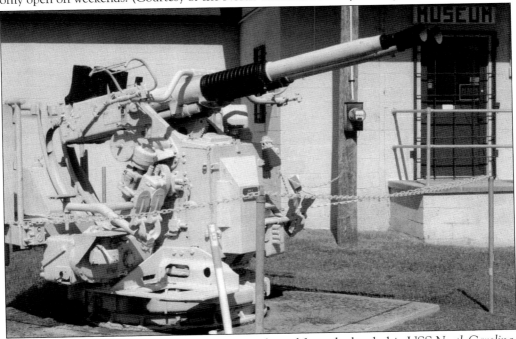

A 40-millimeter antiaircraft machine gun was salvaged from the battleship USS *North Carolina*, which is now a World War II tourist attraction moored near downtown Wilmington's docks. (Courtesy of the North Carolina Military History Museum.)

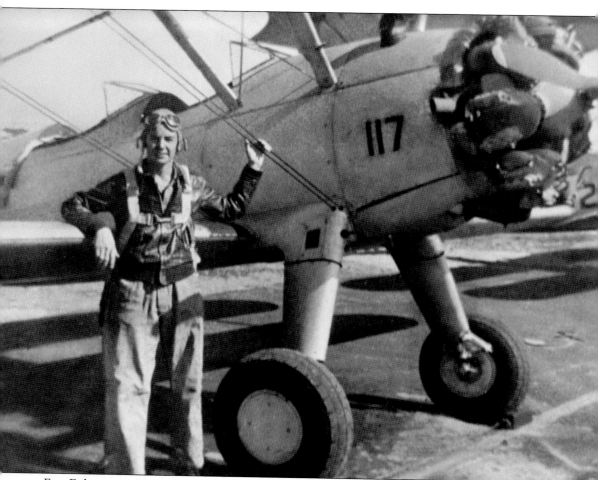

Fort Fisher was a World War II antiaircraft artillery training ground where practice rounds were fired at 20-foot nylon targets towed behind planes that flew parallel to the beach. Great care was taken not to shoot down the plane itself, and quite a few of those very brave pilots were women. (Courtesy of the Gilbert Burnett.)

Four

FORT FISHER

Col. William V. Lamb was the man in charge of Fort Fisher during the Civil War. With tons of sand, he created elevated earthen battlements that could absorb and withstand shell blasts, an idea influenced by the Malakoff Tower, which protected the Russian port Sevastopol during the Crimean War. Union troops had to stage two separate assaults in December 1864 and January 1865 to take the fort. Two weeks later, photographer Timothy H. O'Sullivan (1840–1882) took the photographs that appear on the following pages. (Courtesy of the North Carolina State Archives.)

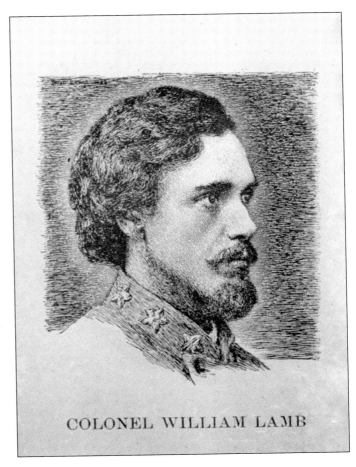

COLONEL WILLIAM LAMB

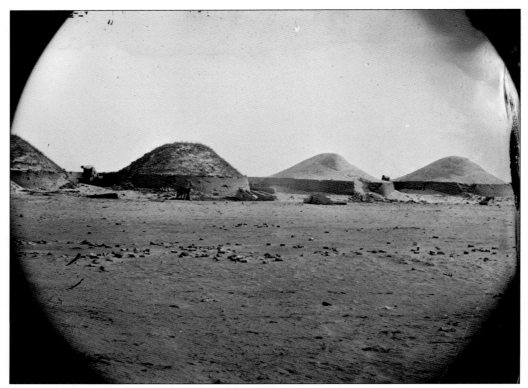

Here is a view of the traverses guarding the Cape Fear River. Union blockaders were hard put to prevent blockade-runners from slipping past them under the cover of Fort Fisher's cannons. As a result, Wilmington was the last port of the Confederacy to remain open, and it had rail connections with Virginia. (Courtesy of the Library of Congress.)

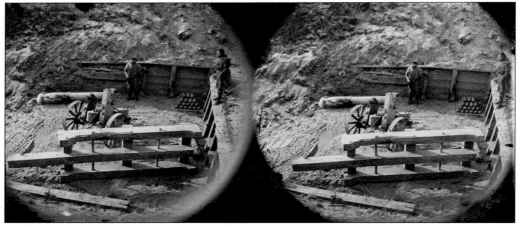

A dismounted gun is seen in the interior of an emplacement. Federal blockaders tried to cover the 50-mile mouth of the Cape Fear River, dodging treacherous shoals while staying out of range of Fort Fisher's guns. A series of sand batteries, built during the first year of the war, defended the fort on all sides—land, sea, and the river. Other defenses included Shepherd's Battery on the river and Batteries Mead, Cumberland, Hedrick, and Bowls on the ocean. Together these fortifications mounted only 17 guns, but it was always a work in progress. (Courtesy of the Library of Congress.)

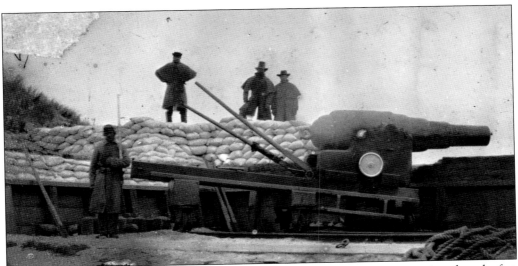

This is another interior view, with an English Armstrong gun. Construction continued on the fort right up to the opening shots of the first bombardment on December 24, 1864, and even then, the project was not finished. The channel leading to New Inlet ran parallel to Fort Fisher's sea-facing battlements, so blockade-runners going that route were given excellent protection. Guarding the Old Inlet on the other side of the river was Fort Caswell on Oak Island. Some blockade-runners were captured, some were sunk, and some were beached in order to salvage the cargo, but still the successes far outnumbered the failures. By the fall of 1864, nearly 50 Union blockading vessels worked to close the port of Wilmington. (Courtesy of the Library of Congress.)

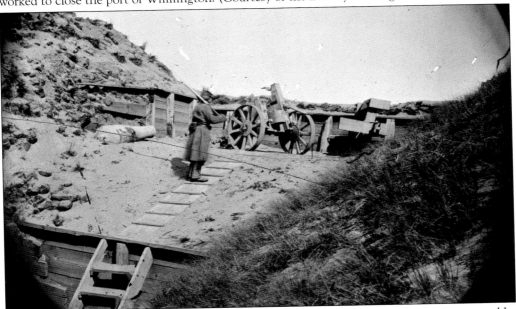

While the Federals dithered on a plan of attack, the fort grew stronger and more impenetrable. The Union wanted to use ironclads but feared that large ships could not safely enter the New Inlet for a rear attack. It also seemed unlikely that a purely naval attack would succeed. From the spring of 1863 until the summer of 1864, they deliberated on a combined land and sea assault. (Courtesy of the Library of Congress.)

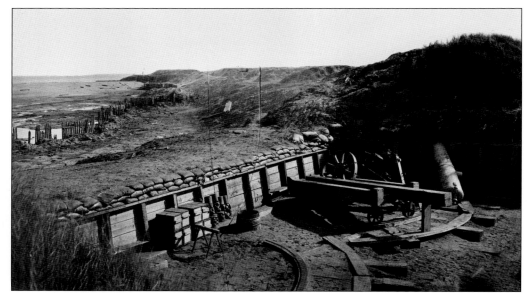

This view of the land face shows a destroyed gun carriage in the second traverse. By the fall of 1864, the land face of the fort was about 500 yards long and mounted 25 guns protected by 32-foot mounds or traverses. The traverses rose 12 feet above the gun chambers and contained rooms used as powder magazines and bomb rooms. A series of broken passageways ran the length of the land face, and at the center was a heavily guarded entrance. A nine-foot palisade fence north of the fort ran from the river to the ocean. (Courtesy of the Library of Congress.)

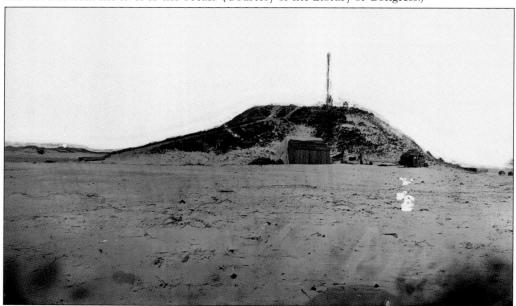

Battery Lamb faced south. The sea face was made up of a series of connected batteries extending about 1,400 yards and mounting 22 guns. Located at the end of the sea face was the 60-foot Mead Battery, and a half-mile to the southwest was Battery Buchanan, a four-gun battery that overlooked New Inlet, the Cape Fear River, and the southern approach to Fort Fisher. (Courtesy of the Library of Congress.)

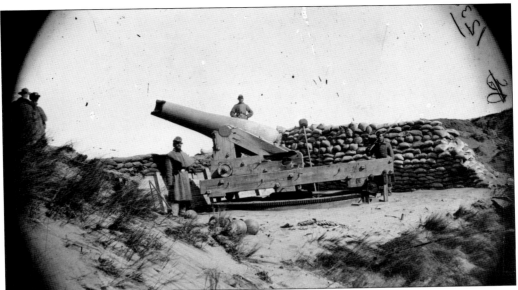

Note that the cannon's muzzle has been shot off. Adm. David Porter commanded the Union navy, and Generals Scottford Whitesel and Benjamin Butler commanded the army. On December 23, they positioned the USS *Louisiana* near the fort, loaded with over 200 tons of explosives. The detonation was supposed to destroy part of the earthworks and create confusion, but instead, it served as a wake-up call. Fort Fisher was severely outmanned and outgunned and took as many as 10,000 shells that day. The Confederates answered with only 672. (Courtesy of the Library of Congress.)

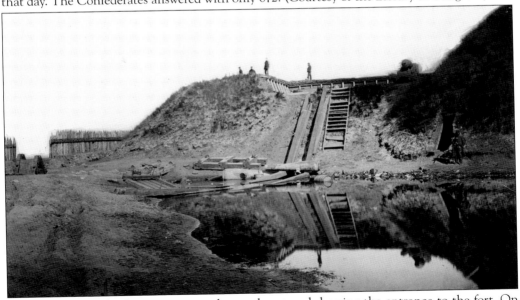

This is a view of the first traverse on the northwest end showing the entrance to the fort. On Christmas morning, the Federals landed troops above Fort Fisher and advanced to within 50 yards of the land face. But on second thought, the generals concluded the fort could not be taken without a general siege, and they were unprepared for that. They evacuated all but 700 troops that night and withdrew the rest two days later. The Union fleet steamed away. (Courtesy of the Library of Congress.)

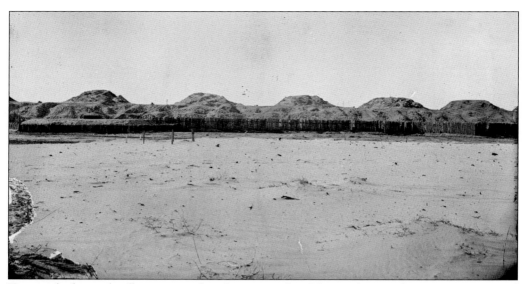

Two weeks later, the fleet returned with an armada of 58 warships and 19 transporters and landing barges. The bombardment began on January 13, while 18,000 troops were landed north of the fort. On January 15, another 2,000 sailors and marines landed. The Confederates were fewer than 2,000 men, and many of them were killed before the fort fell. Fort Fisher withstood as many as 50,000 shells during the two battles, and the principle damage was to the palisades and the guns and their carriages. The bomb rooms, magazines, and passages were still in good condition. (Courtesy of the Library of Congress.)

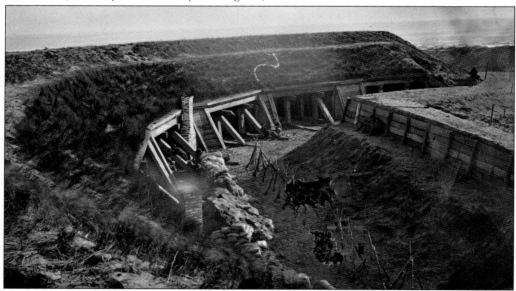

This is an interior view of "the Pulpit." Today, a state historic site houses several exhibits, and a reconstruction of Shepherd's Battery stands on the river side of what little remains of the fort's land face. Across the highway, a memorial to the Confederate dead is on Battle Acre, and at the southern end of Federal Point near the Southport–Fort Fisher ferry landing is a remnant of Battery Buchanan. Some sources claim that the attack on Fort Fisher was the greatest naval bombardment in the history of the world. (Courtesy of the Library of Congress.)

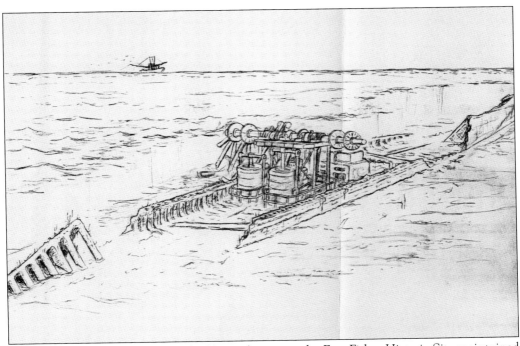

Beneath the Waves is an exhibit building adjacent to the Fort Fisher Historic Site maintained by the North Carolina Underwater Archeology Laboratory. Offshore, the remains of the *General Beauregard* (formerly *Havelock*) lie submerged, a side-wheel steamer used as a blockade-runner. The *General Beauregard* was built in Glasgow, Scotland, in 1858 and was 223 feet in length with a beam of 26 feet and a draft of 14 feet. The USS *Howquah* chased her aground on December 11, 1863, and Confederates burned her to prevent her from being salvaged by Union forces. After storms, candles washed ashore from the wreck. (Courtesy of Leslie Bright.)

A gazebo overlooks the submerged remains of the shipwrecked *General Beauregard*. (Courtesy of the Federal Point History Center.)

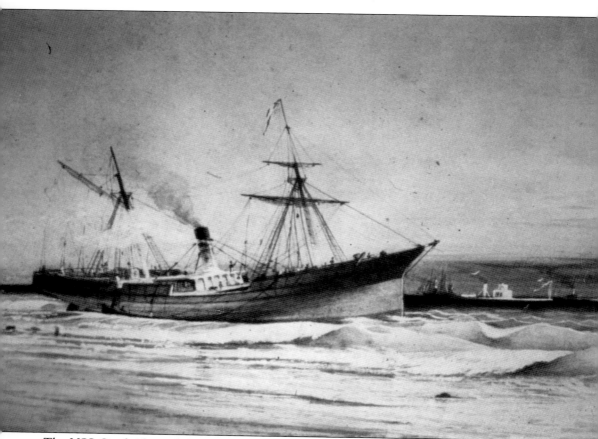

The USS *Cambridge* and the USS *Stars & Stripes* chased the blockade-runner *Modern Greece* onto the beach on June 27, 1862. She was built in Stockton, England, in 1859 and was 210 feet long with a beam of 29 feet and a draft of 17 feet. She carried a cargo of Enfield rifles, hand tools, swords, and bayonets and now lies about 200 yards offshore in 25 feet of water. (Courtesy of the North Carolina Underwater Archeology Laboratory.)

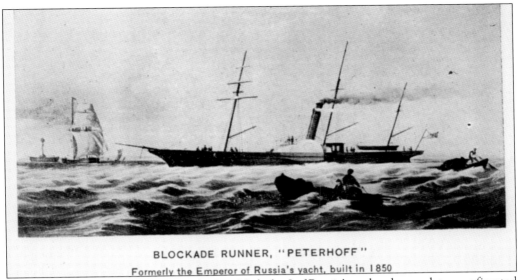

BLOCKADE RUNNER, "PETERHOFF"
Formerly the Emperor of Russia's yacht, built in 1850

The vessel USS *Peterhoff* was formerly Czar Nicholas I of Russia's yacht; she was later confiscated by the British during the Crimean War and, even later, was used as a blockade-runner during the Civil War. She was 210 feet long, with a beam of 28 feet and a draft of 15 feet. In 1863, while running the blockade, she was captured, sold to the Department of the Navy, and commissioned into the Union navy. She was then deployed as a blockader to Wilmington in order to block New Inlet. She collided with the USS *Monticello* and sank in 30 feet of water two miles off Fort Fisher. (Courtesy of the North Carolina Underwater Archeology Laboratory.)

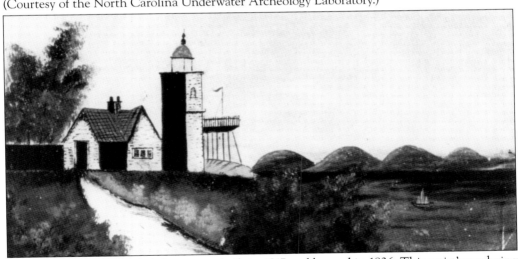

The original Fort Fisher lighthouse was built in 1817 and burned in 1836. This artist's rendering shows the second lighthouse, built on the same foundation in 1837 and still standing when Fort Fisher was built. That was unfortunate, because the Confederates soon realized that Union ships were using it to establish their range of fire and fix their sights. It was about 60 feet tall and it had to come down, if for no other reason than that the lighthouse keeper's house right next to it was Colonel Lamb's headquarters. Confederates started dismantling it from the top in January 1863, with a man named Alfred Campen working on scaffolding to chip away at the structure. One of the walls collapsed entirely, and both man and scaffolding were completely crushed. (Courtesy of the Federal Point History Center.)

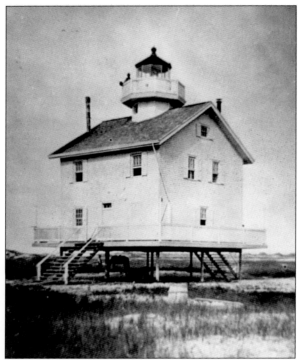

The third Fort Fisher lighthouse was built in 1866, and in the background of this photograph, off on the hazy horizon, are the earthen mounds that were once the land face of Fort Fisher. In the foreground, wooden headboards mark the graves of fallen Confederate soldiers; these were later moved to Wilmington's Oakdale Cemetery. The lighthouse burned in 1881. (Courtesy of the Federal Point History Center.)

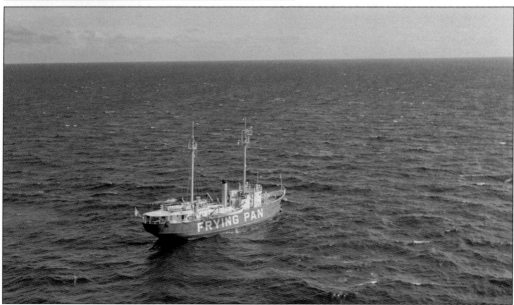

A series of offshore light towers and light ships over the years have warned oceangoing vessels of the shallow waters of Frying Pan Shoals extending from the southeast end of Bald Head Island. This one was used from 1930 to 1942 and was taken out of service during World War II. It was back in place from 1945 to 1964, and then for a time it became a floating maritime museum in Southport. A private speculator bought it and moved it to New York. (Courtesy of the North Carolina State Archives.)

The Frying Pan Shoals Light Tower was built in 1966, automated in 1979, and deactivated in 2003, when GPS technology rendered the tower obsolete. It is 80 feet tall, and its platform has two floors. The lower floor is roughly 5,000 square feet and includes seven bedrooms, a kitchen, an office, storage area, and a recreation room. In 2010, the Coast Guard sold it to a private individual who plans to convert it into an offshore platform for fishing and diving enthusiasts. (Courtesy of the North Carolina State Archives.)

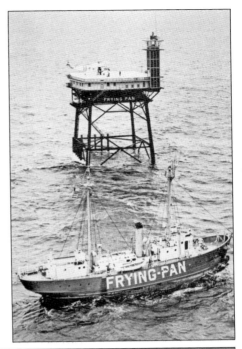

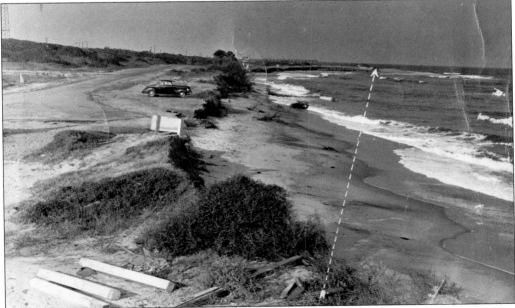

Walter Winner drew the arrow on this October 1946 photograph to show the extent of the erosion at Fort Fisher. The arrow shows where the land mass used to be, and one can see the pier he built in the background. An exhibit at the Fort Fisher Historic Site further laments the loss of the majority of the earthen embankments at this significant Civil War site. Some of them were lost to Highway 421, and some were leveled for a World War II airstrip, but the majority has succumbed to the ocean's waves. The company that paved the road used coquina shells dug out of the shoreline, which very likely contributed to the problem. (Courtesy of Jay Winner.)

Among many other projects, architect Henry Bacon (1866–1924) designed the Lincoln Memorial in Washington, DC, and also created "the Rocks" at the tip of Fort Fisher in order to close off New Inlet. The dam is made of 16,756 gross tons of granite and was constructed from 1875 to 1889, deepening the channel from 7 to 16 feet. Intrepid residents of Pleasure Island have discovered that during low tide they can walk (or wade) the 18 miles to Bald Head Island along the Rocks. Fishing is also a very popular activity at the Rocks. (Courtesy of the North Carolina State Archives.)

In 1985, Dwight and Pam Smith from Charlotte visited the Rocks, which is still a scenic spot even in the wintertime. It might be the only place on the entire island where one can watch a sunrise over the Atlantic Ocean as well as a sunset over the Cape Fear River. (Courtesy of the New Hanover County Public Library, *Star-News* Image Archive.)

The Fort Fisher Hermit lived in a World War II–era munitions bunker from 1955 to 1972. Robert Harrill attracted quite a crowd, estimated in the hundreds of thousands, running the battleship USS *North Carolina* a close second as the leading regional tourist attraction. He taught simplicity, self-reliance, optimism, determination, and a respect for nature to people who sat on rocks and logs around his campfire. (Courtesy of Doris Bame.)

MAY 1959

The Hermit laid out a cast-iron skillet to collect small donations. Unfortunately, local thieves and thugs conceived certain notions as to how much money the old man was collecting, and the Hermit was plagued with nocturnal visits from the resident lowlifes. On the night of June 4, 1972, he allegedly was assaulted by unknown assailants and suffered what officials benignly pronounced to be a fatal heart attack during the incident. (Courtesy of Fred Pickler.)

The Hermit dug a well, planted a garden, rigged up a fishing boat, and shared his bounty with his many visitors. Stray dogs went into the surf with him and herded fish toward his nets. Harrill escaped from a mental institution at age 62, after he grew up in an abusive family, was chucked out of the seminary, was abandoned by his wife and children, failed at a string of jobs, and lost his oldest son to suicide. (Courtesy of Fred Pickler.)

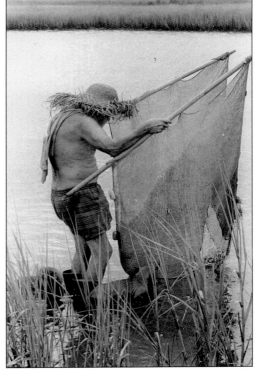

The Hermit demonstrated his shrimping techniques while sharing his values with his legion of disciples. He also said he was writing a book. Many thought he looked like Ernest Hemingway, but a better comparison would be Henry David Thoreau, who also was not technically a hermit but wrote in support of the same ideals. Both Harrill and Thoreau spent at least one night in jail. (Courtesy of Fred Pickler.)

Fred Pickler worked with the sheriff's department and visited the Hermit often. Pickler received an anonymous tip from an eyewitness to the alledged murder, who was digging clams when he saw three teenage boys go into the bunker. "Robert was killed by some people who went down there not to kill him but to harass him," Pickler said. "It went bad on them." The Hermit went limp while the boys roughed him up. (Courtesy of Fred Pickler.)

The Fort Fisher Hermit Society was active for many years to promote principles of personal responsibility and accountability. The society worked with the Harrill family to celebrate what would have been the Hermit's 100th birthday in 1993 and, on other occasions, presented slide shows, talks, bunker tours, and a look-alike contest. Members have written books and put up websites. Fred Pickler is the author of *Life & Times of the Fort Fisher Hermit*. (Courtesy of Fred Pickler.)

The Hermit's bunker is still there next to a historical kiosk located along the Basin Trail that originates at the Fort Fisher Recreational Area. The state has made it a bit difficult to access in an effort to prevent any more crazy old men from taking up permanent residence. It is very appropriate that the bunker is almost in the shadow of the North Carolina Aquarium. The Hermit liked kids as much as he liked dogs and would set up little aquatic displays to entertain and enlighten them. He advocated the creation of a state-run aquarium, and now, here one is right in his own backyard, with two others up the coast at Pine Knolls and Roanoke Island. The Hermit's grave can be found down a dirt trail off Dow Road, decorated with a cast-iron skillet on top of a bed of oyster shells. The epitaph reads, "He made people think," followed by the dates February 2, 1893, to June 4, 1972. "I was born on Ground Hog Day and I've been trying to hibernate ever since," he often said. (Courtesy of Doris Bame.)

BIBLIOGRAPHY

Barnes, Jay. *North Carolina's Hurricane History*. 3rd ed. Chapel Hill: UNC Press, 2001.

Block, Susan Taylor. *Cape Fear Beaches*. Charleston, SC: Arcadia Publishing, 2000.

Burnett, Gilbert. Personal interview. June 28, 2011.

Cecelski, David S. *The Waterman's Song: Slavery and Freedom in Maritime North Carolina*. Chapel Hill: UNC Press, 2001.

Edwards, Jennifer. "A Color Line in the Sand: African-American Seaside Leisure in New Hanover County, North Carolina." Thesis. Wilmington: UNC-Wilmington, 2003.

Fort Fisher State Historic Site. Film and tour, 2011.

Freeman, William. Personal interview. February 13, 2011.

Hall, Lewis Philip. *Land of the Golden River*. Vol. I. Wilmington: Wilmington Printing Co., 1975.

Henson, Elaine. Postcard History Series: *Carolina Beach*. Charleston, SC: Arcadia Publishing, 2007.

Pickler, Fred. Personal interview. February 12, 2010.

Discover Thousands of Local History Books Featuring Millions of Vintage Images

Arcadia Publishing, the leading local history publisher in the United States, is committed to making history accessible and meaningful through publishing books that celebrate and preserve the heritage of America's people and places.

Find more books like this at
www.arcadiapublishing.com

Search for your hometown history, your old stomping grounds, and even your favorite sports team.